THE LONGEST CAPTURE THE FLAG MATCH EVER. OF ALL TIME.

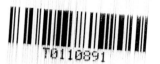

Do you ever wonder why we're here?

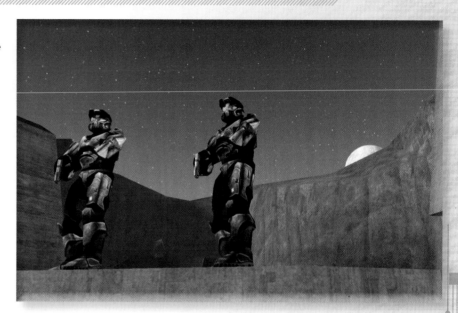

In an era when gamers can broadcast live to thousands of fans, it's hard to imagine a time before online video. Now the second-largest search engine in the world, YouTube was still years away back in 2003, when five friends unleashed a sci-fi comedy epic known as *Red vs. Blue* onto the Internet.

Fast-forward more than a decade, thirteen seasons, and 250+ episodes later: *Red vs. Blue* is not only the web's longest-running series, but the longest-running sci-fi series in American history.

While some have only heard the series mentioned in passing, it is no stranger to accolades. Every year, tens of thousands of attendees arrive in Austin, Texas, to celebrate its creators, Rooster Teeth, at a convention called RTX. It has won countless awards, inspired scores of would-be Internet superstars, and popularized machinima, a form of filmmaking that marries computer animation with real-time puppeteering. While network suits stared at computer monitors wondering if there was any money to be made in web video, Rooster Teeth had already laid the groundwork for an online empire in *Red vs. Blue*.

But how did we get here?

Some would call the show's success a cosmic coincidence—a product of perfect timing and a built-in audience in the form of *Halo*® fans. After all, what gamers hadn't sat on their couches in the early 2000s and wondered why Halo's jeep was called the "Warthog," and not some other kind of animal? *Red vs. Blue* gave voice to their late-night multiplayer binges, with capture the flag matches that ended in the early hours of the morning . . . red and blue flags waving against the purple light of dawn.

Others might say it was all part of a divine plan—tactical decisions that set the standard for a number of today's fledgling new media start-ups. Weekly video releases, an open relationship with the show's audience before anyone knew the words "social media," and just the right amount of elbow grease all made *Red vs. Blue* more than a phenomenon, but

a blueprint for how to get famous on the Internet.

Mega outlets like the *New York Times, Entertainment Weekly,* and *WIRED* have all covered the phenomenon at great length—how it began, the way it became viral before viral was a household word, and how it became a thriving franchise.

But not as many have written about the show's true colors, the ones that lie beneath the armor. To fans, the impact of *Red vs. Blue* isn't about its method, or the fact that most everything on-screen is performed by a player holding a controller. Fans don't care about whether or not the show was seen by Microsoft and Bungie within days of its release. They're more concerned about what's going to happen to Tucker, Simmons, and Grif. They can't wait for the next time Caboose interrupts a conversation, or to see more information revealed about the mysterious Project Freelancer.

So why are we here, then?

We're here to celebrate a world that is brighter and bigger than the pixels in which it takes place. We're here to relive the highs and lows of a show that is older than most programs on network TV, yet continues to find new ways to tell its ever-growing story. We're here to take a Warthog ride through *Red vs. Blue*'s vast universe, which expands all the time to include new desolate canyons, badder bad guys, and more people ready to give these idiotic soldiers a chance.

Oh, and by the way—shotgun.

>> *DO YOU EVER WONDER WHY WE'RE HERE?* << —*SIMMONS*

[WARNING]

PROJECT FREELANCER SIMULATION FILES COMPROMISED. . .
AUTHORIZING LOGIN CREDENTIALS. . .

> USER: ADMIN
> PASSWORD: PASSWORD

DATA CORRUPTION DETECTED. . .
AI PRESENCE FOUND. . .

CAUTION!

ROGUE AI UNIT HAS INFILTRATED OUR SYSTEM. PLEASE PROTECT ALL
CLASSIFIED DOCUMENTS. BROWSE THESE SIMULATION FILES AT YOUR OWN
RISK. TO MINIMIZE RISK OF FURTHER INFECTION, AVOID CLICKING ON ANY
SUSPICIOUS BASEBOOK ADS.

AI UNIT IDENTIFIED. . .

DELTA ‹‹‹

At present, it seems Delta only wishes to update our files with helpful
commentary. As a firsthand witness to many of the accounts in these
archives, his observations have proven both insightful and informative.
CLASSIFICATION Friendly

Dear Director,

The loss of military equipment is a severe infraction. I should not need to remind you that all UNSC property, especially our more experimental technologies, must be kept from the hands of our enemies at all costs. In these trying times, vigilance is paramount.

Yours truly,

Malcolm Hargrove

Assistant to the Oversight Subcommittee Chairperson

Dear Director,

Your request for more bases in which to conduct your experiments was reviewed, with much reservation by our Chairperson. Project Freelancer has been entrusted with one of our military's most valuable assets.

Oversight becomes a much more difficult process if your operations are not centralized. Nonetheless, we have granted your request. However, we reserve the right to revoke this approval as we see fit.

I sincerely hope this does not happen, and anticipate you will not give us occasion to do so.

Yours truly,

Malcolm Hargrove

Assistant to the Oversight Subcommittee Chairperson

CHARACTER DOSSIERS

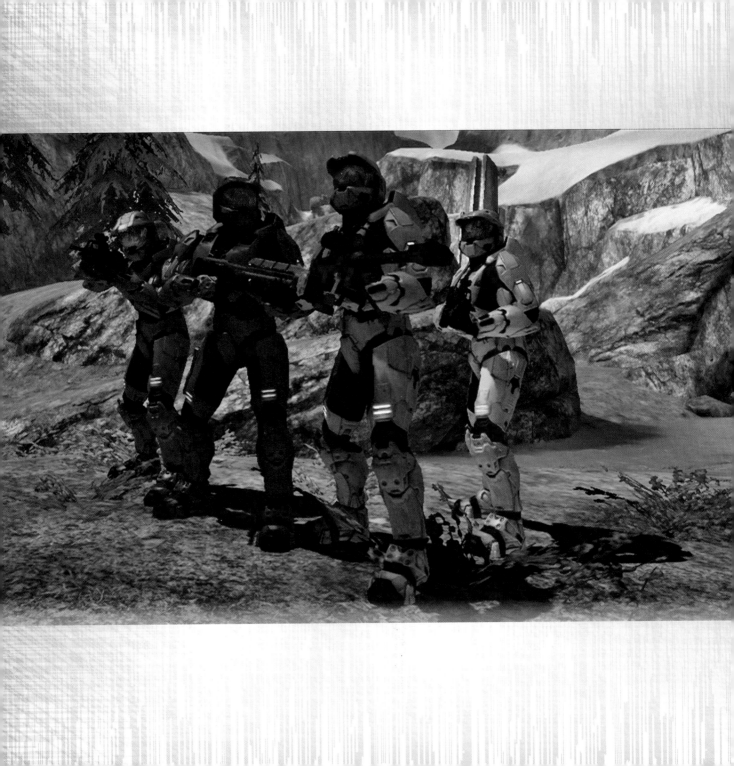

THE BLUES

Welcome to the most volatile army this side of the galaxy. Despite frequent roster changes and organizational restructures, the Blues maintain a shaky foothold on one half of Blood Gulch. Throughout the prolonged skirmish at Simulation Outpost 1, Blue team swaps leaders on more than one occasion—from a well-spirited Freelancer to a mean-spirited AI (and then a mean-spirited Freelancer, for kicks).

While they only make up half of an epic conflict, the Blue team's impact on the galaxy can't be overstated. One of its members becomes a hero of legend to an alien race's religion. Another of its members used to be the AI Alpha, the key to a covert operation called Project Freelancer. And the other is named Caboose. Together, they negotiate surrenders, banter about dongles, determine the best vehicles for picking up chicks, and wage eternal war against the Reds.

CHURCH

» I AM THE BEST. «

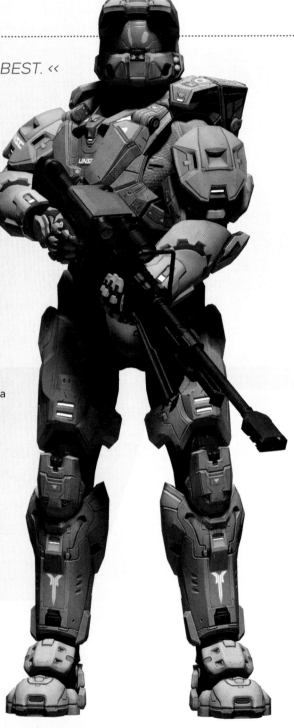

NAME: Private Leonard Church

KNOWN ALIASES: Alpha, Epsilon, Director

COLOR: Cobalt

WEAPON PROFICIENCY: Sniper Rifle ... sorta

POSITION: Self-Appointed Leader

NOTABLE ATTRIBUTES: Being cranky. Delivering exposition. Missing targets at close and long ranges.

BACKGROUND: Private Leonard Church can barely be called a soldier—not only because he's technically a computer program, but also because he's terrible at being a soldier in general.

Church's true identity isn't Leonard Church, but the artificial intelligence designated as Alpha. Based on the mind of the Director of Project Freelancer, Church's collection of memories aren't actually his own. He was hidden in Blood Gulch to keep Project Freelancer's dirty deeds under wraps. Unfortunately, Church's commanding officer, Captain Butch Flowers, died from an overdose of

» MY NAME IS LEONARD CHURCH, AND YOU WILL FEAR MY LASER FACE. «

aspirin, leaving Church to assume command. (Oddly enough, Church himself may or may not have administered the aspirin to Captain Flowers while stuck in a "time loop.")

Learning that he's an artificial intelligence program isn't Church's only misfortune. Throughout his military career he has suffered a humiliating death at the hands of a teammate, possessed multiple members of the Red team, been resurrected as a floating orb, and been reunited with his former love, Tex, only to lose her on multiple occasions.

Church as the Reds and Blues knew him disappeared after his heroic sacrifice to stop The Meta. The entity currently calling himself Church is actually the AI unit Epsilon—Alpha's memories.

And like any good memory, he is fading.

>> HOLY CRAP! WHO IS RUNNING THIS ARMY!? <<

>> THERE'S A FINE LINE BETWEEN NOT LISTENING AND NOT CARING. I LIKE TO THINK I WALK THAT LINE EVERY DAY OF MY LIFE. <<

>> BOO, MOTHERFUCKER. <<

TUCKER

NAME: Private First Class Lavernius Tucker

COLOR: Cyan/Aquamarine/Teal

WEAPON PROFICIENCY: Badass Sword/Key Thing

POSITION: Chairman of Love

NOTABLE ATTRIBUTES: Picking up chicks in an assortment of vehicles. Stabbing things with a badass sword. Hearing double entendres from a great distance. Father of the year.

REQUESTS: To hold the Sniper Rifle, just once.

BACKGROUND: Lavernius Tucker is a member of the Blue team formerly stationed at Blood Gulch, and the father of the first human-alien baby. He was transferred to the simulation army because he pretended to be a licensed military physician named Dr. Cloitus. A not-so-natural leader, Tucker is also second-in-command of the Blues by default, because God help everyone if Caboose ever takes over.

Tucker is often distracted by women and has a penchant for slacking off. Despite his disdain for military decorum, he often shows flashes of brilliance in combat, such as when he defended an alien temple from a dig team for months without backup, when he stopped the Freelancer Wyoming's hostile takeover of the universe with the AI Omega, and when he tricked the mercenary Felix

>> BOW-CHICKA-BOW-WOW! <<

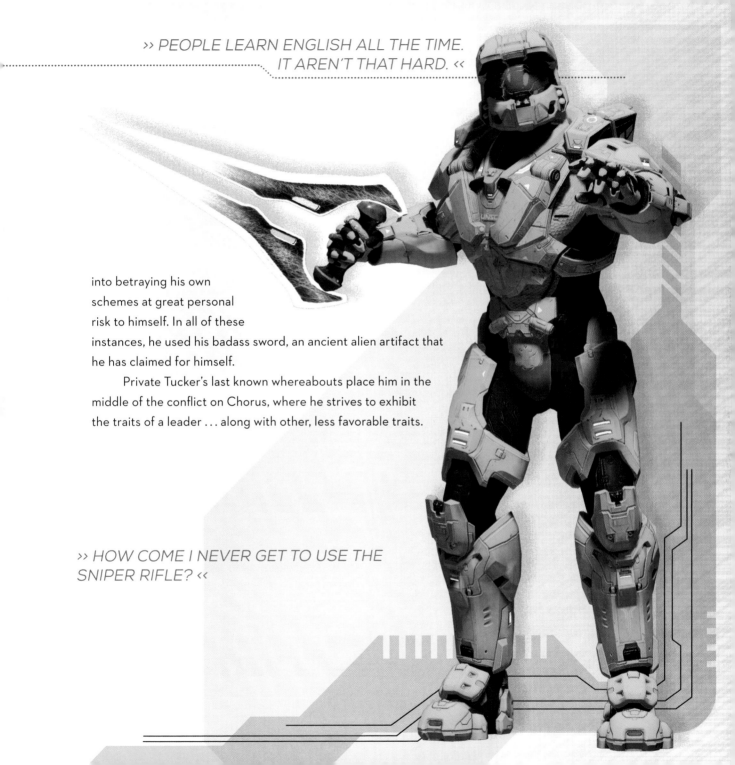

›› PEOPLE LEARN ENGLISH ALL THE TIME.
IT AREN'T THAT HARD. ‹‹

into betraying his own schemes at great personal risk to himself. In all of these instances, he used his badass sword, an ancient alien artifact that he has claimed for himself.

Private Tucker's last known whereabouts place him in the middle of the conflict on Chorus, where he strives to exhibit the traits of a leader ... along with other, less favorable traits.

›› HOW COME I NEVER GET TO USE THE
SNIPER RIFLE? ‹‹

CABOOSE

NAME: Private/Captain Michael J. Caboose

COLOR: Standard Blue

WEAPON PROFICIENCY: Super Strength

POSITION: Team Rookie/Occasional Captain/Church's Best Friend

NOTABLE ATTRIBUTES: Carrying heavy things. Explaining complicated plot points clearly and concisely. Helping teammates by shooting at them. Driving manual transmission vehicles.

DISLIKES: Tucker. Babies. Taxes. Yellow Guy.

BACKGROUND: To classify Caboose's intelligence as "Exceedingly Below Average" would pay him a huge compliment. Prior to his post at Blood Gulch, Caboose was stationed on a low-gravity outpost on a remote moon. There, he received multiple demerits for endangering teammates by having zero concept of how breathing works in space (hint: it doesn't). Once he arrived at Blood Gulch, Caboose quickly killed his leader, Private Church, compromising one of the most expensive AI units in the UNSC's employ.

>> MY NAME IS MICHAEL J. CABOOSE . . . AND I. HATE. BABIES! <<

DELTA The musical theme for Freckles, Caboose's favorite pet, is set to the walk cycle of the Mantis robots from *Halo 4*. The theme, like much of *Red vs. Blue*'s iconic music, was created by Nico of *Trocadero*.

And that's just the tip of the iceberg. Not only does Caboose blatantly disregard the rules, he doesn't even know what the word "rules" means. He's killed soldiers in nearly every base he's stepped foot in, and isn't even entirely aware of how to spell his own name, much less how to load his gun with anything other than confetti.

Despite all that, Caboose boasts some of the Blues' greatest accomplishments. He is currently the highest ranked soldier out of both the Reds and Blues, having been promoted to Captain during an argument on the planet Chorus. Caboose also plays host to a millennia-old, super-advanced alien AI, whom he named "Santa."

WASHINGTON

NAME: David ███████

KNOWN ALIASES: Agent Washington, Wash, Recovery One, Prisoner 619-B

COLOR: Steel or Cobalt, Yellow Trim

WEAPON PROFICIENCY: Battle Rifle

POSITION: Freelancer-in-Charge

NOTABLE ATTRIBUTES: Surviving. Holding grudges. Disposing of bodies. Following beacons.

BACKGROUND: Agent Washington is a former Freelancer and Recovery agent who helped bring down Project Freelancer after meeting up with the Reds and Blues. During his time with Project Freelancer, Washington was implanted with the tortured AI Epsilon. The AI tried to kill itself inside of Washington's head, resulting in a psychotic break. When Washington recovered, he possessed memories of all of the Director's crimes, and a long list of scores to settle.

» I DON'T GET PAID ENOUGH FOR THIS. «

Washington's history with the Reds and Blues is fraught with difficulty. At times he has ordered them around, beaten them to a pulp, shot them, and

DELTA According to his psych profile in Command's database, Washington used to be a chronic bed wetter.

stolen their identities, before ultimately becoming part of the gang. His time in Project Freelancer led to the development of deep-seated trust issues and cynicism, but joining up with Blue team has helped to warm Wash's cold, cold heart (even if they do drive him nuts). The Ex-Freelancer now hopes to put his past behind him.

But the past is not always willing to go quietly.

>> HOW ABOUT, MINOR JUNIOR
PRIVATE GRIF, NEGATIVE FIRST
CLASS? <<

THE REDS

Whether they're advancing on the Blue base at Blood Gulch or spying on a lone Blue at Valhalla, the Red team always finds a way to render even the simplest of military operations completely FUBAR.

What the Reds lack in execution, they make up for in diversity. The Red squad comes from every walk—and serial number—of life. There's Sarge, the experienced but ineffective Southern gentleman who specializes in overcomplicated campaigns of violence. Simmons, the one-eighth cyborg with Dutch-Irish roots. Grif, the lazy freeloader who shirks his duties in new and creative ways. Donut, who enjoys short walks on the beach preceded by a long day at the sauna. And Lopez, the Spanish-speaking mechanic robot.

The Reds won't rest until they've rooted blue hues out of every corner of UNSC space. But given their track record against such few soldiers, that might be a rather lengthy campaign.

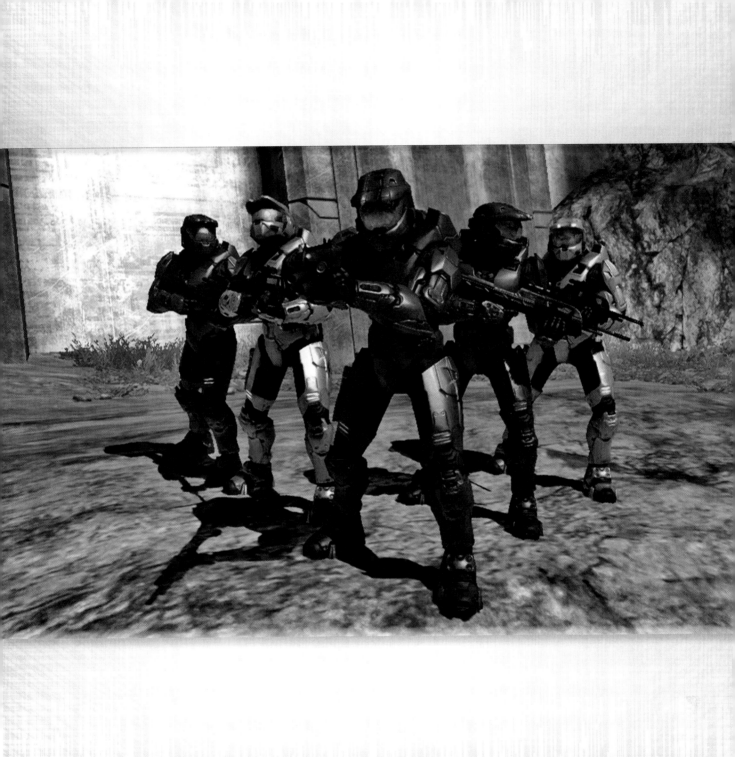

SARGE

NAME: Sarge

COLOR: Red, like the blood of his enemies

WEAPON PROFICIENCY: Shotgun

POSITION: Colonel

NOTABLE ATTRIBUTES: Tough love. A penchant for robotics. Classic misdirection. Corporal punishment. Pep talks. Negotiating his team's surrender.

BACKGROUND: Sarge is the gruff leader of the Red outpost at Blood Gulch. While he insists he was born and raised in the military (with a lieutenant for a wet nurse), Sarge hails from the Deep South on Earth. Although our records can't pinpoint when he enlisted, we do know Sarge dabbled in robotics during his early years in the military. He was jettisoned from the ODSTs after causing irreparable damage to his unit's ship. The cause? Building the ship's navigation AI a "body fit for skedaddlin'."

Sarge is completely ineffective as Red team's leader. His plans are often unnecessarily grandiose and full of nonsensical ramblings. An untold number of military dollars have been

>> *HOW ABOUT A TASTY LEAD SANDWICH WITH A SIDE OF SARGE! HOLD THE LIFE. AND THE MAYO.* <<

 DELTA When Sarge readies to go find Grif and Simmons after a troubling call from Command in *Season 6: Reconstruction*, his favorite suitcase features bumper stickers of several stages from Joseph Campbell's "Hero's Journey": Supernatural Aid, Crossing the Threshold, Call to Adventure, and Refusal of the Call.

wasted on building doomsday devices and weather machines, and ordering something called "robot nuts" by the barrelful.

Even though he is still listed as AWOL for not reporting to his new post after the events of Blood Gulch, Sarge recently demanded a promotion to Colonel. Not even a frozen paycheck can stop him from hunting pesky Blues.

According to reports, Sarge lived out his lifelong dream of pulling off a slow-motion Warthog maneuver in combat during the Battle of Crash Site Alpha on Chorus. One can only wonder what the old man will accomplish next.

>> MY FAVORITE PART WAS THE PART WHERE YOU DIED. ENCORE! BRAVO. <<

SIMMONS

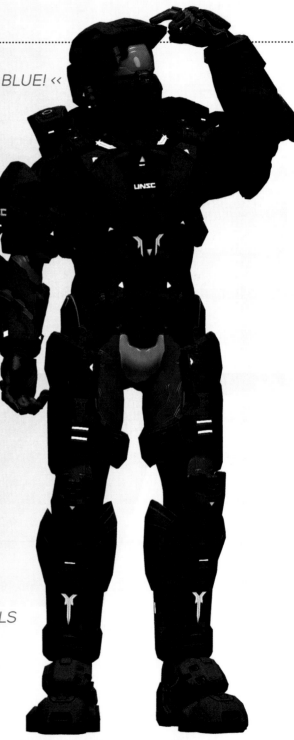

>> SUCK IT, BLUE! <<

NAME: Private Richard "Dick" Simmons

COLOR: Maroon

WEAPON PROFICIENCY: Whatever Sarge Says

POSITION: Team Kiss-Ass

NOTABLE ATTRIBUTES: "Book-smarts." Brownnosing. Turncloaking. Tidying up. Hacking. Overdependence on father figures. Taunting the Blues.

BACKGROUND: Private Simmons is the Red team's second in command, proficient in following orders and complimenting superiors. After a poor timed-test score and one too many commanding officers calling his constant need for attention disruptive, Simmons was enrolled into the simulation program at Blood Gulch and quickly found himself one of the canyon's smartest inhabitants (which isn't saying much).

>> I REALLY DON'T LIKE IT WHEN GIRLS PAY DIRECT ATTENTION TO ME. <<

Throughout his post at the Red army (and occasionally the Blue army, when the mood strikes him), Private Simmons has proven his technical prowess. He jury-rigged a nexus of teleporters to save his teammates, infiltrated Command's secure database to help Sarge delete the opposition, and posed as a Blue soldier to gather valuable intel about the other team (never mind that he also assaulted them with a make-believe tank).

Although he is fiercely loyal, Simmons's desperation for approval and instruction can lead him astray. He needs a firm hand to keep him in line . . . or perhaps some good therapy.

>> *WHO'S A BAD HOSTAGE TAKER NOW, BITCH?* <<

>> *YES, SIR!* <<

>> *WHY DO I HAVE TO PLAY IN THE WOMEN'S LEAGUE?! I WANT TO BE A MATHLETE, DAD! A MATHLETE!* <<

GRIF

NAME: Minor Junior Private, Negative First Class Dexter Grif

COLOR: Orange

WEAPON PROFICIENCY: Alien Weapons

POSITION: Slacker Extraordinaire

NOTABLE ATTRIBUTES: Piloting vehicles. Getting hit in the nuts. Retreating. Forgetting ammo. Consuming food. Napping with his helmet on. Ignoring orders.

BACKGROUND: Dexter Grif is by far the laziest member of the Red team, and is last in the chain of command—even if someone ahead of him kicks the bucket. He is of such low importance to the team that Sarge regularly threatens bodily harm and occasionally administers it himself by way of his trusty Shotgun.

Before Blood Gulch, Grif was stationed on a doomed colony that was wiped out during the Great War. Grif only survived the enemy's ambush because he was sleeping at his post. Both friendlies and aliens walked right past him during the battle, assuming he was KIA. Grif

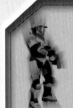

DELTA The *Halo* game type Grifball, which involves smashing an orange Spartan with a Gravity Hammer, was created by Rooster Teeth and popularized by its fans.

>> *I WANT YOU TO UNDERSTAND, SARGE, IT'S NOT BECAUSE I'M LAZY . . . IT'S BECAUSE I DON'T LIKE YOU . . . OR RESPECT YOU . . . IN ANY WAY.* <<

>> *BLUE TEAM PROBLEMS.* <<

transferred to Blood Gulch soon after.

Even though he is apathetic toward pretty much everything, Grif shows the occasional dash of cleverness. He once administered CPR for a bullet wound to the head, and displayed an entrepreneurial spirit by selling Red ammunition to the highest bidders (the Blues) at Rat's Nest. Not to mention his numerous and often creative attempts to be court-martialed. Grif always seems to apply himself when it really matters—he assisted in the defense of Crash Site Bravo with his creative use of future cubes, and even coordinated with his team to help defeat The Meta once and for all.

Currently, Grif contributes his skills (or lack thereof) to the struggle for Chorus.

›› *I WOULD JUST LIKE TO LET EVERYONE KNOW THAT I SUCK.* ‹‹

DONUT

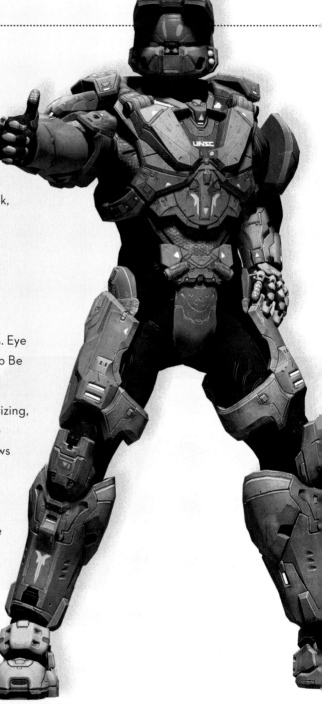

NAME: Private Franklin Delano Donut

KNOWN ALIASES: Commander Pop n' Fresh, Daisy Dukes, Cupcake, Easy Listening, Pretty in Pink, Princess Bubblegum

COLOR: Light-ish Red

WEAPON PROFICIENCY: Grenades

POSITION: On all fours . . . cleaning Red base

NOTABLE ATTRIBUTES: Great at tossing things. Eye for fashion and interior design. Voted Most Likely to Be Fabulous. Speaks Spanish at a 9th grade level.

BACKGROUND: Private Donut's love for accessorizing, fashion, and assisting his teammates in deep tissue massages has certainly raised a number of eyebrows in Blood Gulch. A purveyor of awkward moments, Donut is one of Red team's newest recruits, having been transferred after violating the UNSC's strict policy against cheese and wine hours in the middle

>> *BACK ON THE FARM, I USED TO THINK ABOUT THINGS. THEN REPRESS THOSE THOUGHTS.* <<

of field exercises. Naturally, his antics are a much better fit in a squad with more colorful personalities, especially if the personalities are idiots.

Though it earned the rookie ridicule at first, Donut's light-ish red daywear is now a source of pride. Donut has demonstrated his worth with more than just decor advice. Not only is he the only Red to successfully penetrate Blue defenses to steal the flag, he also killed the Freelancer Tex with one of the greatest grenade throws of all time. If facing Private Donut in battle, be warned: he's harder to get rid of than a wine stain. The Red rookie has survived being shot, blown up, and dehydrated. He also endured three whole weeks without a manicure.

>> SIMMONS! I NEED YOUR OVARIES! <<

>> WHO WANTS TO HOLD MY ANKLES WHILE I STRETCH OUT MY HAMMIES? <<

>> SOY NO ROJA. SOY ROJA-ISH! <<

LOPEZ

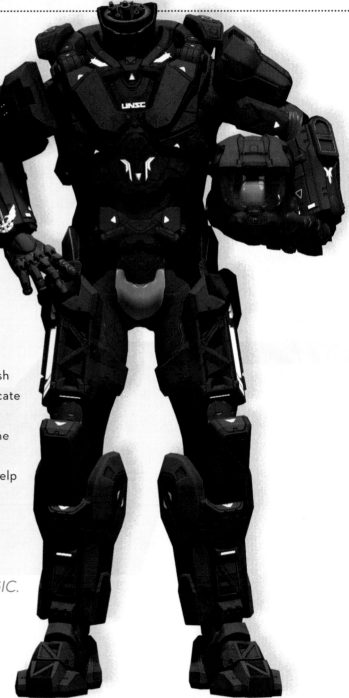

NAME: Lopez the Heavy

COLOR: Brown

WEAPON PROFICIENCY:
Wrenches

POSITION: Fixer-Upper

NOTABLE ATTRIBUTES: Tolerance.
Singing love ballads. Storing important
info in his *cabeza*.

BACKGROUND: Lopez is the Reds' oft
misunderstood Spanish-speaking robot.
Created by Sarge without a proper English
speech unit, Lopez is unable to communicate
with his teammates—although he (rather
unfortunately) understands every word the
Reds say, they are unable to understand
what he says. The Reds do their best to help
by speaking loudly and slowly.

*>> CAN I FIX THEIR RADIO FROM
HERE? SURE. BECAUSE I AM MAGIC.
I AM A MAGIC ROBOT. <<*

There is perhaps no greater victim of the war than Lopez, who has been repurposed as a silent observer, a Blue slave, a weather machine, and just a head. Though he actively despises his teammates, Lopez endures their flawed schemes, idiotic questions, and constant barrage of destroyed vehicles.

Although it would be understandable, do not confuse Lopez with Lopez 2.0, the replacement robot built by Sarge on Chorus, who happens to be kind of a jerk.

>> I'M GOING TO ERASE EVERY MEMORY OF YOU THE SECOND YOU LEAVE. JUST LIKE I DID FOR [FILE DELETED] AND [FILE DELETED]. <<

>> WHY DO YOU BOTHER TO REPLY IF YOU DON'T UNDERSTAND WHAT I SAY? <<

FRIENDS, ENEMIES, AND IN BETWEEN

Whether they're advancing the plot or just providing a laugh, the ancillary characters of *Red vs. Blue* add an extra splash of color to the show's ever-expanding cast, from Command on down. Explosive, duplicitous, nefarious, outrageously stupid, or on treads, each of these personalities has its own part to play, even if that part is to kill one of the Reds and Blues now and then.

DOC/O'MALLEY

>> I LETTERED IN TRACK IN HIGH SCHOOL! IT WAS THE LEAST DIRECTLY COMPETITIVE SPORT I COULD FIND! <<

NAME: Medical Officer Frank DuFresne/O'Malley

COLOR: Purple (but black as evil on the inside, of course)

WEAPON PROFICIENCY: Medical Scanner/Rocket Launcher

POSITION: Canyon Medic, Galactic Overlord

NOTABLE ATTRIBUTES: Ushering the universe toward oblivion. Making people more comfortable while they die. Evil plans. Holistic living. Prolonged multi-dimensional travel.

BACKGROUND: Medical Officer Frank DuFresne (aka Doc) began his career by failing out of the homeopathic medicine program at Jamaica State. With nothing better to do, he enlisted in the war as a pacifist and conscientious objector, providing medical assistance to both Reds and Blues as needed. After his exile from both teams for being a terrible medic, Doc was infected by the megalomaniacal Omega AI and transformed into the evil, psychotic O'Malley.

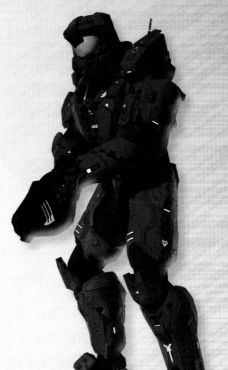

Doc soon found himself an unwilling co-conspirator in Omega's plans to rule the universe. While inhabiting the same mind, the two personalities didn't see eye to eye on a number of issues. But even though they couldn't agree on property value, pronunciation, and the division of evil fortress chores, they still managed to be a thorn in both Red and Blue armor on numerous occasions.

Doc/O'Malley was last seen on the planet Chorus. He claims to have disappeared for months on a journey through time and space, but nobody seems to recall his absence.

>> THEY WILL ALL TASTE OBLIVION! WHICH TASTES JUST LIKE RED BULL®! WHICH IS DISGUSTING! <<

SISTER

>> WHAT'S THE GREY GUY SO UPSET ABOUT? <<

NAME: Kaikaina Grif

KNOWN ALIAS: Sister

COLOR: Yellow (But she's color blind. She could be magenta for all she knows.)

WEAPON PROFICIENCY: Magnum

POSITION: Team Bicycle

STATUS: Possibly deceased. Probably not. Likely pregnant and/or high on prescribed antibiotics.

NOTABLE ATTRIBUTES: Finding anything and everything to be hot. Embarrassing the family. Tribal drum beats. Identifying cops.

BACKGROUND: Kaikaina Grif is Dexter Grif's sister, who also happens to be dumber than a bag of rocks ... and Caboose. She arrived in Blood Gulch after hijacking a ship and stealing equipment, which would have been the most successful thing she'd ever accomplished, were it actually true. After a long and tenuous standoff with Sarge and Lopez at Blood Gulch, Sister was allegedly killed by Lopez, who had suffered one too many late-night raves from Blue base.

>> YOU KNOW HOW CIRCUSES HAVE A BEARDED LADY AND A FAT LADY? WELL MY MOM PLAYS BOTH, 'CAUSE SHE IS LIKE, SUPER TALENTED! <<

DELTA Sister's name has only been used in outside-of-the-series features and has never actually appeared in an episode.

>> THAT'S KINDA HOT! <<

ANDY THE BOMB

NAME: Andrew D. Kaboom

POSITION: Bowling Ball

PRIMARY SKILLS: Exploding. Counting backward from 10. Zingers.

BACKGROUND: Built by Agent Tex, Andy was originally meant to destroy O'Malley's evil fortress at the power station. Tex constructed Andy from a disassembled protocol robot, which gives Andy not only the ability to talk, but also to translate languages. This made Andy a critical piece of the events leading up to O'Malley and Wyoming's attempts to defeat and enslave the aliens, along with Tex's betrayal of the Reds and Blues. Current whereabouts are unknown.

>> *HEY, YOU CAN'T MAKE AN OMELET WITHOUT BLOWING UP A FEW EGGS!* <<

>> *WHAT AM I GONNA DO? ROLL THERE? PICK ME UP, YOU DUMB BITCH!* <<

DELTA When Tucker uses Siri to play a dance theme in Season 11, Episode 12, Siri attempts to call Andy instead.

SHEILA/FILSS

>> MY LOGICAL DATA ANALYSIS SECTOR INDICATES THAT WOULD BE HIGHLY UNLIKELY. AND MY BULLSHIT METER AGREES. <<

NAME: Sheila / Freelancer Integrated Logistics and Security System (FILSS)

WEAPON PROFICIENCY: Big Cannons

PRIMARY SKILLS: Locking targets. Packing lunches. Talking to Caboose.

BACKGROUND: Sheila and FILSS are both part of the same AI tutorial program that helps simulation troopers and Freelancers operate vehicles. While FILSS assisted in the Mother of Invention's primary functions in Project Freelancer, Sheila resides in the M808V Main Battle Tank delivered to the Blues in Blood Gulch. Her status as a vehicle didn't stop her from becoming embroiled in a bitter love triangle with Lopez and Caboose, which led to a robot revolution from the former and a nasty AI infection from the latter. Someone ought to teach this girl about protection.

In terms of their last known whereabouts, Sheila barely functions in the downed Pelican airship in Valhalla, while FILSS is speculated to have been illegally moved to Malcolm Hargrove's warship, the *Staff of Charon*.

>> WHAT IF I DECIDED I WASN'T BLUE'S TANK? WHAT IF TODAY, I'M FEELING JUST A LITTLE BIT RED? <<

VIC

NAME: Virtual Intelligence Computer (VIC)

POSITION: Blue/Red Command

PRIMARY SKILLS: Remaining calm, dude. Confusion. Inspiring the Reds and Blues with helpful pointers.

BACKGROUND: VIC is the AI program in charge of running the simulation troopers at Blood Gulch. Posing as a contact at Command, VIC is actually housed in a computer beneath Blood Gulch Outpost Alpha, where it issues helpful orders like "do better than you are currently doing" and "please try harder to win."

When VIC accidentally tipped its double identity to Tucker, it hired notorious bounty hunter and Ex-Freelancer Wyoming to assassinate the Blue, resulting in Wyoming's arrival and subsequent torment of the Reds and Blues. VIC was eventually shut down when the simulation at Blood Gulch unraveled completely.

>> *IF YOU WANT TO TALK, DON'T EMAIL. AND DON'T YOU CLICK, CLICK, CLICK, CLICK. JUST CALL ME UP AT 555-V-I-C-K!* <<

>> *WINKY BLINKY THE ONE-EYED SERGEANT'S FIRIN' BLANKS . . . VAYA CON DIOS TO THE VAS DEFERENS . . . I MEAN A VASECTOMY, DUDE.* <<

PROJECT FREELANCER

Project Freelancer was a top secret program that existed to ensure the security of humanity in a harsh and violent galaxy. Under the supervision of Dr. Leonard Church, Project Freelancer paired artificial intelligence with highly trained soldiers to give them a greater chance of surviving the alien enemies of the Great War.

The soldiers of Project Freelancer were tested to their physical and mental limits. While driving agents to fierce competition bettered the program's results, it left former participants as the walking wounded—many of Project Freelancer's participants lost their minds or their lives.

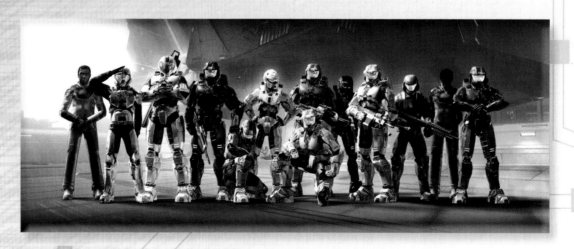

THE DIRECTOR

>> WHILE THE LAW HAS MANY PENALTIES FOR THE ATROCITIES WE INFLICT ON OTHERS, THERE ARE NO PUNISHMENTS FOR THE TERRORS THAT WE INFLICT ON OURSELVES. <<

NAME: Dr. Leonard Church

AI PROGENY: The Alpha, Church, created in his mind's likeness

NOTABLE ATTRIBUTES: Unparalleled drive and determination to the point of moral ambiguity. High intelligence. Manipulation.

BACKGROUND: A cold and calculating man, Dr. Leonard Church is the former Director of Project Freelancer. He was relieved of his command after the UNSC Oversight Subcommittee divulged the nature of the Director's illegal activities with his program's AI. He believed that any course of action was necessary to prevent the extinction of the human race—even torturing his own mind.

In the early days of Project Freelancer, Dr. Church was granted a single "smart" AI—Alpha, which he based off his own mind. Church's project had unforeseen consequences when the Alpha split itself, producing an AI fragment that represented his late wife, Allison. This glimpse into the depths of the Director's grief gave birth to an idea—fracturing the AI even further to produce more personalities.

The Director tortured Alpha until the AI cordoned off portions of its mind to protect itself from going insane. Different AI entities surfaced as a result: rage, logic, deceit, trust, memory. Once the Director had more AI units to toy with, he increased the scope of Project Freelancer, which only widened the net of those hurt by his machinations . . . including his daughter, Agent Carolina.

The Director took his own life after being confronted by Agent Carolina and Epsilon in the Freelancer Offsite Storage Facility. In the end, his fixation on resurrecting the love from his past prevented him from anticipating the dismal legacy he would leave for the future.

>> WHEN FACED WITH EXTINCTION, EVERY ALTERNATIVE IS PREFERABLE. <<

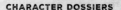

COUNSELOR PRICE

NAME: Price

NOTABLE ATTRIBUTES: Soothing tones. Psychoanalysis. Matchmaker extraordinaire.

BACKGROUND: Counselor Price acted as the Director's right-hand man during Project Freelancer, developing many of its unique methodologies.

Using his detailed psych profiles on each of the Freelancers, the Counselor helped the Director create the ideal soldiers by teaming each agent with an AI that complemented them emotionally and psychologically. With an extensive background in psychology and psychoanalysis, the Counselor also provided much of the research that helped the Director fracture the Alpha AI into multiple personalities.

After Project Freelancer shut down, the Counselor's role shifted to Recovery, a special operations branch of Project Freelancer. There, he worked with Freelancers to retrieve missing AI units, going so far as to use his agents as bait to draw out The Meta.

The Counselor's latest stomping grounds were aboard the UNSC prison ship *Tartarus,* a ship that was recently hijacked by a band of space pirates and their rather famous mercenary leaders, Felix and Locus. He is now believed to be in the employ of one of Project Freelancer's greatest rivals, Malcolm Hargrove.

Given his track record, it's only a matter of time before his newest project meets its end.

>> SO YOU WOULD SAY THAT YOU HAVE OVERWHELMING FEELINGS OF ANGER, AND A NEED FOR REVENGE? <<

TEX

NAME: Allison Church

KNOWN ALIAS: Agent Texas

COLOR: Black

AI DESIGNATION: Omega—Rage

EQUIPMENT: Active Camouflage

WEAPON PROFICIENCY: Everything

NOTABLE ATTRIBUTES: Kicking ass (and nuts). Being a mean lady. Resurrection.

›› *PAYBACK'S A BITCH, AND SO AM I.* ‹‹

BACKGROUND: Agent Texas was the reason for Project Freelancer's existence. After losing his wife in the Great War, Dr. Church searched for a new way to defeat the enemy. One night, the Alpha AI, based on the Director's mind, purged itself of the grief that haunted the Director. The resultant new AI fragment was the embodied memories of his lost love, Allison. He gave her the rank of Agent Texas and disguised her with a suit of black armor.

Tex quickly became the Director's most prized soldier. Tex's trip up the leaderboard landed her the powerful AI Omega, much to the chagrin of Allison's daughter, Agent Carolina. Forming a special bond with Agent Texas, Omega drove her to terrifying lengths as she sought to succeed at all costs—even hurting those she cared about most.

At Blood Gulch, Tex enlisted the help of the Reds and Blues to rid herself of Omega. She was eventually consumed by The Meta after she shipwrecked in Valhalla.

Like the rest of Project Freelancer, Agent Texas is now deactivated. Yet her memory lives on, again and again.

DELTA: In the Season 10 episode "Remember Me How I Was," the password Tex uses to open CT's encrypted file on Beta is "Allison."

THE META

NAME: ██████████

KNOWN ALIASES: Agent Maine, The Meta

COLOR: Primarily White (frequently changes his secondary armor)

AI DESIGNATION: Sigma—Creativity

WEAPON PROFICIENCY: Brute Shot, Brute Strength

NOTABLE ATTRIBUTES: Snarling. Growling. Glowering. Skulking. Lurking. Stealing. Murdering. High tolerance for pain. Audio editing.

BACKGROUND: The Meta was quite possibly the most frightening and single-minded enemy the Reds and Blues have ever faced. A terrible by-product of Project Freelancer, the agent formerly known as Maine was corrupted by the sinister creativity of his AI, Sigma. Sigma took advantage of Maine's recovery after a devastating injury to Maine's throat. The AI convinced Maine to aid Sigma on a quest to achieve Metastability, a state in which an AI might be considered human. This seduction changed Maine's identity to The Meta, a creature bent on reuniting Project Freelancer's AIs.

The Meta's quest for AIs was cut short by an EMP blast that wiped out all of its collected AIs, including the Alpha himself. In their greatest victory to date, the Reds and Blues finished The Meta once and for all on the cliffs of Sidewinder.

Maine's helmet and armor are believed to be in the possession of Malcolm Hargrove, who has made a hobby of collecting trophies from Project Freelancer.

>> [INCOMPREHENSIBLE GROWLING] <<

YORK

NAME: ▮▮▮▮▮

KNOWN ALIASES: Agent New York, Foxtrot-12

COLOR: Gold, Silver Trim

AI DESIGNATION: Delta—Logic

EQUIPMENT: Healing Unit

PROFICIENCY: Lock-picking

POSITION: Team Scoundrel

>> D, GIMME A DRUMROLL. <<

NOTABLE ATTRIBUTES: Picking locks. Witty commentary. Palling around with Delta. Watching his right side.

BACKGROUND: Agent York was the infiltration expert of Project Freelancer. Recruited for his locksmith skills, York received one of the first AI implantations due to his high leaderboard rank. His AI, Delta, remained with him until the end of his life, years after the events of Project Freelancer.

During a training battle, Agent Wyoming nearly killed Agent York by using live ammunition. The accident left York blind in one eye, and would have been worse if not for the intervention of Agent Texas. York repaid Tex by aiding in her break-in to free the Alpha. Years later, Tex enlisted York's help one more time, offering him the chance to get revenge against Wyoming. Though Delta advised York against this course of action, York agreed—a decision that ultimately cost him his life.

Several reports were filed against Agent York claiming he and Agent Carolina had something of a "personal" relationship in addition to their professional interactions. Freelancer Command was unable to find any proof to support these accusations.

CAROLINA

NAME: ▮▮▮▮▮▮▮

KNOWN ALIASES: Agent Carolina

COLOR: Teal

AI DESIGNATION: Eta and Iota—Fear and Happiness

EQUIPMENT: Speed Boost, Adaptive Camouflage

WEAPON PROFICIENCY: Plasma Rifles, Battle Rifle, Grappling Hook, Fists

NOTABLE ATTRIBUTES: Strives for perfection. Extremely aggressive.

BACKGROUND: Agent Carolina was the team leader of the Freelancers, as well as their best soldier—until Tex arrived. The daughter of Director Church, Agent Carolina grew up in the shadow of her deceased mother.

Carolina's obsession with being better than her mother haunted her quite literally in the form of Tex. Unknown to Carolina, Agent Texas was the memory of Allison. The two competed against each other on numerous occasions at the Director's behest.

Carolina's constant need for perfection drove her to disrupt the AI implantation process, which largely contributed to the implosion of Project Freelancer, and the disastrous consequences that followed. Carolina's ambitions harmed her further during the Freelancer break-in, when, in her blind pursuit of Texas, she was brutally assailed by The Meta and left for dead.

Carolina spent the next few years in hiding before hunting down Epsilon to find and kill the Director. However, rather than taking her vengeance, she forgave the old man and decided to move on with her life. She will no longer be held back by the events of the past.

>> *CALL ME 'SWEETIE' AGAIN, AND THERE'S GOING TO BE A KNIFE INSIDE OF YOU.* <<

WYOMING

NAME: Reginald ▮▮▮▮▮▮

KNOWN ALIASES: Agent Wyoming

COLOR: White

AI DESIGNATION: Gamma—Deceit

WEAPON PROFICIENCY: Sniper Rifle

PRIMARY SKILLS: Avoiding defeat. Time manipulation. Lying in wait. Knock-knock jokes.

BACKGROUND: Knock, knock. Who's there? A lethal bounty hunter with a penchant for trickery.

The ability to slip past enemy defenses made him a natural partner for the AI Gamma, Alpha's deceit. Unfortunately for Wyoming, Gamma forcibly removed itself for protection following an attack by Agent Maine. Agent Wyoming hasn't been the same since.

Wyoming first met the Reds and Blues when he was conscripted by VIC to kill Private Tucker, who discovered that Reds and Blues shared the same Command. He later established an alliance with O'Malley to take Tucker's alien son captive, a plot that very nearly ended the war and enslaved an entire alien race.

Wyoming escaped death like it was a hobby—he eluded Maine, Tex, York, and Washington in separate attempts on his life, always using his time-manipulation unit to change outcomes that he saw as unfavorable. His antics were ended by Tucker's Energy Sword.

>> LOOKS LIKE IT'S YOUR LUCKY DAY, MATE. DON'T HAVE TIME TO TORTURE YOU, SO I'M JUST GOING TO HAVE TO KILL YOU. <<

NORTH AND SOUTH

NAMES: ▮▮▮▮▮▮ and ▮▮▮▮▮▮

ALIASES: Agent North Dakota/Agent South Dakota

COLOR: Purple, Green Trim

AI DESIGNATION: North—Theta, Trust / South—N/A

EQUIPMENT: North—Domed Energy Shield / South—N/A

WEAPON PROFICIENCY: North—Sniper Rifle / South—Battle Rifle, Explosives

CURRENT STATUS: North—KIA / South—Extra Crispy

NOTABLE ATTRIBUTES: Sibling rivalry.

BACKGROUND: Agents North and South Dakota were recruited into Project Freelancer to observe what happened when one agent received an AI and the other did not. This experiment caused a sharp rift to develop between these twins.

 While Agent North was considerate and nurturing, Agent South was brash and insubordinate. As a result, North was awarded the AI Theta, a childlike unit that needed proper confidence boosting before it could operate at maximum capacity.

>> *THEY SAY THE BEST OFFENSE IS A GOOD DEFENSE.* << —NORTH

>> *WHO'S THE MONSTER NOW, BITCH?* << —SOUTH

CT

>> I'M NOT MAKING EXCUSES FOR MYSELF. WHY ARE YOU? <<

NAME: ▮▮▮▮▮

KNOWN ALIASES: Agent Connecticut

COLOR: Brown

AI DESIGNATION: N/A

EQUIPMENT: Holographic Projection

WEAPON PROFICIENCY: Magnum

POSITION: Defector

NOTABLE ATTRIBUTES: Double agenting. Trading secrets. Uncovering mysteries. Blowing whistles.

BACKGROUND: Agent Connecticut blew the lid off the Project Freelancer conspiracy. Vengeful, angry, and driven, Connie's bitterness about her lowly position in Project Freelancer fueled her defection. While playing double agent, Connecticut learned the exact nature of the Director's experiments, including the many laws he'd broken. CT tried to put this information in the right hands before being killed by Agent Texas in the Freelancer operation on Longshore.

CT's path later crossed with the Reds and Blues . . . sort of. Fatally wounded by Agent Tex, CT managed to escape with the rebel leader, who took her armor, helmet, and name as his own.

>> THEY'RE DRAWING A LINE BETWEEN US, WASH . . . AND YOU'RE EITHER ON ONE SIDE OF THAT LINE OR THE OTHER. <<

DELTA CT is never once seen on the Freelancer Leaderboard.

THE SOLDIERS OF CHORUS

While the rest of the galaxy fought against alien forces during the Great War, the people of Chorus fought among themselves. Chorus, enmeshed in a long and murderous civil war, is a planet filled with psychotic mercenaries, powerful generals, alien secrets, and rookie soldiers who have seen the horrors of war from far too young an age.

On one side of the conflict, the Federal Army of Chorus fights to keep its foothold on the planet that has been long overlooked by the UNSC; they will use any means necessary to maintain order. On the other side, the New Republic seeks to take back their planet from a corrupt and broken government. Both sides fight to create a better future for the people of Chorus, and the Reds and Blues are caught in the middle—making a number of new friends ... and terrifying enemies.

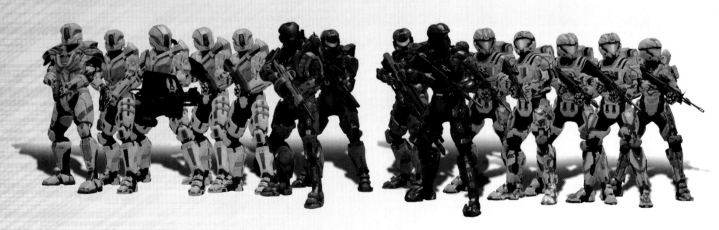

KIMBALL

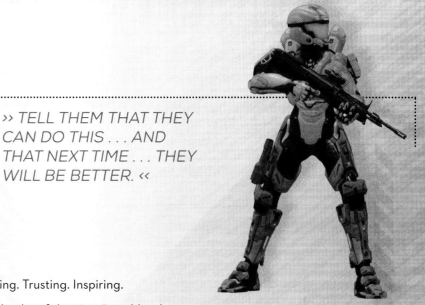

>> *TELL THEM THAT THEY CAN DO THIS . . . AND THAT NEXT TIME . . . THEY WILL BE BETTER.* <<

NAME: Vanessa Kimball

COLOR: Sand, Ice Trim

WEAPON PROFICIENCY: DMR

POSITION: General

AFFILIATION: New Republic

PRIMARY SKILLS: Leading. Hoping. Trusting. Inspiring.

BACKGROUND: Vanessa Kimball, leader of the New Republic, dreams of a brighter tomorrow for her people; a tomorrow where Chorus is no longer under the thumb of the Feds.

At the start of the Civil War, young Vanessa allied with the New Republic. Tenacity moved her quickly through the ranks, but war can weather even the strongest spirit. As leader, Kimball has made decisions she cannot take back. She's seen victory and defeat in unequal portions, and she is running dangerously low on morale (though she doesn't let it show).

When her right-hand mercenary informs her that the Reds and Blues have crash-landed right on her doorstep, she goes to great lengths to recruit them to her cause. Though most people would have probably given up on Grif, Simmons, Tucker, and Caboose, Kimball puts her faith in them. To her, they are the most unbelievable group of heroes the New Republic has ever had.

With a newfound alliance with General Doyle and the Feds, Kimball hopes to finish what she started all those years ago . . . but who knows if any of them can hold out much longer.

>> *I HAVE THE SPEAKING BALL!* <<

JENSEN

NAME: Katie Jensen

COLOR: Sand, Maroon Trim

WEAPON PROFICIENCY: DMR

POSITION: Lieutenant

AFFILIATION: New Republic

PRIMARY SKILLS: Vehicle maintenance. Biology. Algebra. Replacing the rubber bands in her braces with one hand.

BACKGROUND: Lt. Jensen is the eager young technician of Simmons's New Republic squad. Although knowledgeable in machines and gadgets, Jensen is infamous for her clumsiness. While she means well, most soldiers prefer that she stick to the workbench— her attempts to help on the battlefield frequently result in friendly fire accidents.

Years of teasing have given the lieutenant a high tolerance for negativity. Despite not having the best luck, Jensen remains optimistic, determined to make her captain proud . . . and hopeful that she'll get her braces removed someday.

›› NO MATTER WHAT HAPPENS, IT'S BEEN AN HONOR WORKING WITH YOU, SIR. ‹‹

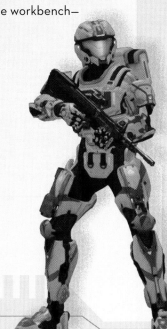

›› SORRY. CHOKED ON MY OWN SPIT. ‹‹

›› YOU WOULD'VE MADE AN EXCELLENT HUMAN SHIELD, PALOMO. ‹‹

PALOMO

>> HI, ME! <<

>> SOMETIMES I LIKE TO TAKE MY HANDS AND CUP THEM AROUND MY EYES . . . LIKE LITTLE HAND-BINOCULARS! <<

NAME: Charles Palomo

COLOR: Sand, Cyan Trim

WEAPON PROFICIENCY: DMR

POSITION: Private

AFFILIATION: New Republic

NOTABLE ATTRIBUTES: Isn't dead yet.

BACKGROUND: In desperate times, humanity cannot rely solely on those willing and able—they must call upon *all* men to fight . . . even the weak, stupid, and really, really, really annoying.

Pvt. Palomo is one of the youngest members of the New Republic, and it shows. His desire to look cool is typically thwarted by his own social awkwardness and short attention span, but you have to give him credit, the kid never stops trying (even though his teammates wish he would). Experiencing war at a young age, Palomo is remarkably desensitized to the violence and danger that constantly surround him. To Palomo, war is just another day on Chorus; sometimes people get shot, sometimes people explode, and sometimes they serve cake in the mess hall.

>> PRIVATE PALOMO: SLAYER OF WOMEN, WOOER OF EVIL! . . . WAIT. <<

>> NOW YOU'RE JUST SPEAKING IN RIDDLES AND YOU KNOW IT! <<

SMITH

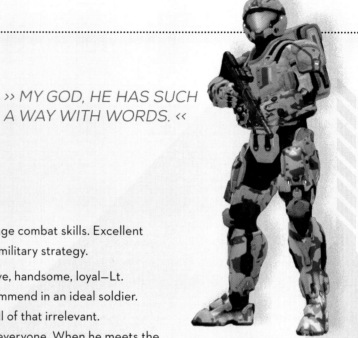

NAME: John "Smith" Andersmith

COLOR: Sand, Blue Trim

WEAPON PROFICIENCY: DMR

POSITION: Lieutenant

AFFILIATION: New Republic

NOTABLE ATTRIBUTES: Above-average combat skills. Excellent physical fitness. Acute understanding of military strategy.

BACKGROUND: Intelligent, strong, brave, handsome, loyal—Lt. Smith possesses qualities most would commend in an ideal soldier. Unfortunately, his blind idealism makes all of that irrelevant.

Smith manages to see the good in everyone. When he meets the "Heroic Reds and Blues," his judgment is clouded by adoration, leading the poor lieutenant to misconstrue every word Cpt. Caboose has ever said as deep, philosophical genius. (On one occasion, Caboose reportedly told Smith his favorite color was "happy." Smith spent the next two days in silence contemplating the rich, complex meaning of this statement.)

>> *MY GOD, HE HAS SUCH A WAY WITH WORDS.* <<

>> *OUR C.O.'S PUT A LOT OF THOUGHT INTO THIS PLAN, SO WHY DON'T YOU SHOW A LITTLE FAITH?!* <<

>> *I BELIEVE CAPTAIN CABOOSE IS THE WISEST INDIVIDUAL I HAVE EVER HAD THE PLEASURE OF MEETING. SIR!* <<

BITTERS

>> ON A SCALE FROM ONE TO TEN . . . I'D SAY WE'RE PRETTY FUCKED. <<

NAME: Antoine Bitters

COLOR: Sand, Orange Trim

WEAPON PROFICIENCY: DMR

POSITION: Lieutenant

AFFILIATION: New Republic

PRIMARY SKILLS: Infiltration and reconnaissance. Bein' nobody's bitch.

BACKGROUND: A more seasoned member of the New Republic, Lt. Bitters has come to accept the fact that he and everyone he knows will probably die a horrible death before the war is over . . . and he wouldn't be surprised if his captain were somehow to blame. Most people would call the young soldier a rebel without a cause, but seeing as he's part of a rebellion, the name hasn't really stuck.

Bitters tends to have a problem with authority figures, especially those he doesn't respect. Although Bitters may have once looked up to Grif as his leader, the lazy orange officer swiftly tarnished his own reputation in his brief time as a New Republic captain. Despite that, Bitters and the other lieutenants have grown in great strides and shown their fortitude during the civil war and the ensuing conflict with Charon's space pirates.

>> I'M BITTERS. MY FUN FACT IS I DON'T HAVE A FUN FACT. <<

>> WHAT'S THE POINT OF THIS, AGAIN? <<

>> THIS WHERE WE PARKIN' THE CARS? <<

DOYLE

NAME: Donald Doyle

COLOR: White, Gold Trim

WEAPON PROFICIENCY:
Scared of Most Weapons

POSITION: Reluctant General, Former Personal Assistant to the Brigadier

AFFILIATION: Federal Army of Chorus

NOTABLE ATTRIBUTES: Excels at speech and debate. Extremely detail-oriented. Bureaucrat. Weenie.

BACKGROUND: The day Donald Doyle learned of his promotion to general, he lost consciousness for six hours, woke up, had a cup of coffee, remembered his reason for fainting, then soiled himself and fainted again. Doyle eventually overcame his initial fear and now leads an occasionally successfully military, due in part to the assistance of the mercenary, Locus . . . of whom Doyle is gravely afraid.

Despite a lack of military acumen, General Doyle used his political skills to maneuver up the ladder in the painfully bureaucratic Chorus government. Ironically, it is this same nonsensical and overly complex system that places Doyle at the head of the Federal Army of Chorus.

Like Kimball, Doyle merely seeks what is best for Chorus. While he admits the former government didn't always serve its people, he passionately believes that rules and order are the only way to restore peace. And while he may be easily intimidated, even the biggest cowards can find glimmers of bravery within themselves . . .

>> I'D LIKE TO QUOTE THE GREAT WILLIAM SHAKE-SPEARE . . . BUT TO TELL YOU THE TRUTH, I DON'T ACTUALLY THINK HE SAID IT. <<

>> AS I'M SURE YOU'VE ALREADY OBSERVED, I AM NOT A BATTLE-WORN SOLDIER, RIPE WITH MILITARY EXPERTISE. <<

GREY

>> I CAN FOAM WHENEVER I WANT, THANK YOU VERY MUCH! <<

>> YOU'RE NO GOOD TO ME DEAD! ALTHOUGH, I SUPPOSE I COULD RUN SOME EXPERIMENTS ON YOUR BODY. <<

NAME: Emily Grey

COLOR: White, Purple Trim

WEAPON PROFICIENCY: N/A

POSITION: (Mad) Doctor

AFFILIATION: Federal Army of Chorus

NOTABLE ATTRIBUTES: 240 IQ. Extensive understanding of biomedical engineering and alien technology. Quite possibly insane.

BACKGROUND: Dr. Emily Grey is nothing short of a genius wrapped in sugar-coated crazy. The brilliant surgeon, one of Chorus's most respected citizens, was considered a prodigy at the age of eleven after diagnosing every patient on the television show *House M.D.* within five minutes of their introduction. (Her parents tried to make her watch *Grey's Anatomy*, but she found the series far too trite.)

Grey's cutesy personality did not exist in her youth. Rather, this bubbly persona developed as a defense mechanism to the Civil War. Surrounded by hopeless patients and gruesome injuries, the young doctor put on a "happy face" to ignore the horrors of war she saw at every turn. Her strategy backfired—as the population of Chorus plummeted, so did Grey's mental stability.

On the bright side, she now carries herself in a perpetual state of glee. Always looking for new ways to entertain her colossal intellect, Emily's side projects include cybernetics, reanimating roadkill, experimenting with alien artifacts, and teaching an automated sentry gun to love. Her newest fascination is the split personality of a certain medic and his former psychotic AI.

>> PSYCHOANALYSES FOR EVERYONE! <<

SHARKFACE

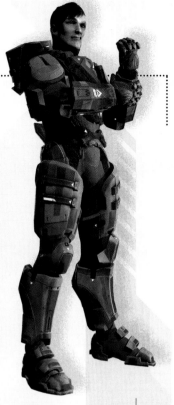

NAME: [UNKNOWN]

FAVORITE COLORS: Black, White, Red

WEAPON PROFICIENCY: Anything with Fire

EQUIPMENT: Hidden Flamethrowers

AFFILIATION: Charon

NOTABLE ATTRIBUTES: Un-ironic, on-the-nose tattoos. Coming back for revenge. Stopping avalanches. Spray-painting.

BACKGROUND: Another almost-casualty of Project Freelancer, the Charon soldier known only as Sharkface rises from the ashes as a game-changer for Malcolm Hargrove's forces during the last phase of the war on Chorus. He previously served Hargrove as one of the elite soldiers who clashed with Project Freelancer on numerous occasions.

After suffering extensive injuries at the hands of Agent Carolina and the rest of the Freelancers during the theft of the Sarcophagus, Sharkface is freed by Felix and Locus while aboard the UNSC prison vessel *Tartarus*. Now, with a head full of steam and a body full of reinforced plating, he's ready to seek vengeance on the woman who helped to kill his comrades and took his life away.

>> *THAT'S IT! THAT'S THE FIRE!* <<

>> *YOU CAN'T RUSH ART, COUNSELOR.* <<

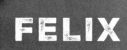

FELIX

>> I AM FUCKING AWESOME. <<

NAME: [UNKNOWN]

KNOWN ALIAS: Felix

>> EVERYONE HAS THEIR PRICE. <<

COLOR: Steel, Orange Trim

WEAPON PROFICIENCY: Mid-Short Range Firearms, Explosives, Knives

EQUIPMENT: Hard Light Shield

POSITION: Mercenary

AFFILIATION: Space Pirate—formerly posing as New Republic

NOTABLE ATTRIBUTES: Deceit and manipulation. Killing for cash. Blocking bullets. Cracking wise.

BACKGROUND: Felix is a mercenary who only loves one thing—himself. Originally fighting for the New Republic, Felix is an extremely capable soldier who knows how to pick his battles (usually the highest-paying ones). Upon first meeting the Reds and Blues, Felix portrayed himself as a greedy, narcissistic goofball with a dark past and cynical outlook on life.

In reality, Felix is a man with an affinity for pain and violence. The Great War opened his eyes to a world where killing was not only accepted, it was part of the job. During this time he became closely acquainted with his squadmate, Locus. Although the two dislike each other on a personal level, they recognize they are unstoppable when working together. This led to a post-war partnership in the contract-killing business.

The two were later hired by Chairman Malcolm Hargrove to con the entire populace of Chorus into destroying one another in civil war. This plan might've succeeded, had it not been for the intervention of the Reds and Blues. Locus and Felix now have no choice but to eradicate the remaining Chorusans themselves, and Felix aims to make the Reds and Blues suffer for their meddling.

It just might be his undoing . . .

LOCUS

>> I'M NOT DOING THIS FOR THE REWARD . . . I'M NOT DOING THIS BECAUSE SOMEONE TOLD ME TO . . . I'M DOING THIS FOR ME. <<

NAME: [UNKNOWN]

KNOWN ALIAS: Locus

COLOR: Steel, Sage Trim

WEAPON PROFICIENCY: Everything

EQUIPMENT: Active Camouflage

POSITION: Mercenary

AFFILIATION: Space Pirate—formerly posing as Federal Army of Chorus

NOTABLE ATTRIBUTES: Combat. Stealth. Interrogation. Thorough understanding of all weapon types. Completing the mission at all costs.

BACKGROUND: Locus is the brutal and efficient mercenary who strikes fear into the hearts of every soldier on Chorus. Twisted from years of battle, Locus answers only to the name of his armor, which he identifies as part of himself. There is nothing in the universe that will stop him from completing his objective—no matter how many of his own soldiers he has to kill to get the job done.

As a man who can no longer identify with humanity, Locus finds the behavior of others both foolish and intriguing. Whereas The Meta was a machine striving to achieve humanity, Locus is a man who considers himself a machine. He is a tool designed to kill . . . and his sights are set on the Reds and Blues.

>> LIKE SHEEP TO THE PEN, YOU'RE READY FOR SLAUGHTER. <<

>> WHICH IS MOST DESERVING OF YOUR HATE? THE MAN WHO FIRES THE GUN? THE MAN WHO MAKES THE GUN? OR THE GUN? <<

THE CHAIRMAN

NAME: Malcolm Hargrove

KNOWN ALIASES: Control, Chairman

POSITION: Former Chairman of the UNSC Oversight Subcommittee, CEO of Charon Industries

NOTABLE ATTRIBUTES: Cutthroat politician. Extraordinary businessman.

BACKGROUND: Malcolm Hargrove's early life could be summarized as "ordinary." Malcolm Hargrove hated his early life.

After decades of hard work and education, Hargrove detached from the world of the mediocre by earning the title of Chairman of the UNSC Oversight Subcommittee. As Chairman, he investigated potential breaches in UNSC protocol, and although the job itself was an exercise in tedium, it did come with one important perk: power. The Chairman used his newfound power to shut down the infamous UNSC splinter group known as Project Freelancer.

As such, Hargrove is viewed by the public as an immovable defender of justice. While he's made the public very aware of his achievements in office, he is less inclined to disclose his actions as the CEO of Charon Industries. Charon is an umbrella corporation with its hands in just about every major market in UNSC space, but its primary focus is weapons and technology.

The Chairman now plans to harvest the plentiful extraterrestrial artifacts of Chorus for his own company. By creating human-alien hybrid weaponry, Charon will leave its competitors back in the Stone Age. All that stands in his way are the last remaining Chorusans ... and a rag-tag team of Red and Blue soldiers.

Once they're dead, he predicts a profitable quarter and successful reelection campaign.

To: The Director of Project Freelancer

From: Counselor

It has come to our attention that the Outpost 1-A incident has placed our Level 0 asset in jeopardy. Director, this asset is critical to ongoing research and my department has been hampered enough by the recent "activity" of our human agents. I understand that your current legal situation prevents us from storing the asset onsite; nonetheless we must make continued efforts to protect it if we have any hopes of continuing our work.

My suggestion? We contact Agent Texas and inform her of the asset's whereabouts. I fully realize that this runs counter to our previous efforts to hide its location from her. However, my profile on Texas is nearly as extensive as my work with the asset. It is my opinion that she will use this information to contact and protect him.

Agent Texas had ample opportunity to pilfer the asset on their last encounter. She did not and she made this choice of her own free will. My profile suggests that she will leave the asset in the place where she feels it is most safe while she continues to gather information to launch her retaliation against this organization. That notion may provide little comfort, but Outpost 1-A is intentionally designed to have no ties back to our project. Motivating Agent Texas to go there would help us on two fronts. She would be protecting our interests while having a diminished ability to investigate us further.

If we can provide her this information via an independent contact, I believe she will cease all her current activities and head there immediately.

As they say, keep your enemies close.

SCOUTING REPORTS

>>>>>>>>>>>>>>>>

How do you build a universe as big as *Red vs. Blue*'s? For starters, it takes more than forty maps and six different video games. Early seasons revolved around a handful of soldiers fighting over a small canyon, but *Red vs. Blue* has since transformed into a grand universe full of intrigue, conspiracy . . . and more canyons. In between those canyons, the Reds and Blues have traveled by foot, exploding Warthogs, and crashing Pelicans to explore evil fortresses, janitors' closets, and even the most forgotten reaches of colonized space.

Halo fans no doubt recognize each of these locations, but *Red vs. Blue* always offers a new context for even the most familiar video game landscapes. Under the show's comedic lens, a slowly turning windmill becomes a razor sharp blade of death (perfect for stopping Warthogs). A malfunctioning teleporter offers a costume change. (Seriously, what is with the black stuff?) And a seemingly innocuous computer terminal kick-starts a "time-looping" rescue operation. In an actual game these props might be overlooked by players in search of the enemy's flag. But *RvB* doesn't just inhabit the places *Halo* fans have experienced for hours on end—it gives them new life altogether.

From canyon walls to desert temples, these are the places our favorite soldiers have bitched about most.

THE SIMULATION OUTPOSTS

When Project Freelancer needed a place for its agents to hone their skills, the UNSC commissioned simulation outposts throughout the galaxy. Stocked full of idiots and dropouts from the military, these outposts provided cannon fodder for the Freelancers to test their mettle and kick some serious ass. Each one is a unique battleground for the ongoing struggle of Red against Blue, and the perfect backdrop for the biggest, fakest war ever.

BLOOD GULCH SIMULATION OUTPOST 1

>> *FAR AS I CAN TELL, IT'S JUST A BOX CANYON IN THE MIDDLE OF NOWHERE, WITH NO WAY IN OR OUT.* <<

Why would anyone ever be here?

Literally nothing more than two bases on either end of a barren canyon, this inconsequential outpost became the center of the UNSC's biggest, weirdest conspiracy. As far as simulation experiments go, Outpost 1 proved to be the most eventful on record. That's probably because Blood Gulch is not only the original home of the Reds and Blues who ultimately shut down Project Freelancer, but was also the hiding place of the Alpha, the project's experimental AI.

But not everything stays hidden for long.

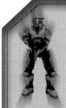

DELTA The ridiculous troubles that befell the Reds and Blues at Blood Gulch were all part of a handbook of preselected scenarios. The events that transpired at Blood Gulch make up Scenario 3.

NOTABLE FEATURES: None. It's just a fucking canyon with two bases, 1-A (Red) and 1-B (Blue). Each base has its own teleporter, one of which exhibits a strange side effect that chars armor with a thin coat of "black stuff." Avoid Tucker's Rock at all costs, as it has not been properly sterilized.

A massive computer in the cave beneath the canyon houses VIC, the program that presided over the Blood Gulch simulation. At some point VIC malfunctioned and no longer reported threats to Alpha's identity back to Command. This resulted in a few egregious errors in security and far too many uses of the word "dude."

IMPORTANT EVENTS: Blood Gulch played host to the hunt for Omega, was the staging ground for the first robot uprising, the birthplace of the first human-alien baby, and the final resting place of the first bodies of Church and Tex— the Alpha and Beta AIs, respectively.

ALTERNATE NAMES: Blood Gulch, Coagulation, Hemorrhage

SIDEWINDER SIMULATION OUTPOST 9

>> *IT'S A PLANET MADE ENTIRELY OUT OF ICE. IT'S REALLY. FUCKIN'. COLD.* <<

The site of multiple climactic encounters between the Reds and Blues, Sidewinder's icy cliffs have literally been shaped by battle. This secret facility was first created after the *Mother of Invention*, the flagship of Project Freelancer, plummeted into the region's sub-zero landscape.

To cover up the blunder that resulted in the release and capture of several top-secret AI units, Project Freelancer did the obvious—they created a fake war and a fake base to cover it up. The simulation outpost at Sidewinder was meant to hide the evidence of Project Freelancer's cataclysmic setback, much to the chagrin of the Red and Blue soldiers stationed there, who think the place really is just too damn cold.

NOTABLE FEATURES: One of Sidewinder's bases houses a harsh jail cell, where inmates have been incarcerated up to several hours at once. Dozens of bodies are buried under the snow, many of which were left by Agent Tex.

IMPORTANT EVENTS This outpost served as a battleground for the Reds and Blues and their enemies on more than one occasion. It is here that they first tangled with Wyoming and O'Malley. And while Sidewinder is not technically the birthplace of the dangerous entity

DELTA There are a total of ten Churches on Sidewinder at once during Season 3.

Dear Chairman,

I write today in response to your committee's request for more information about our program and the suspected incident at Outpost 17-B. No doubt by now you have reviewed the video logs transmitted by our Recovery agents dispatched to the region. I am sure you have seen the empty bases, the barricades constructed by the survivors. The cryptic warning left on the wall. The battles that apparently took place between team members that had turned on one another. And of course, the ship.

While we cannot say for certain, I share your concern that we have an unfortunate post-Project scenario taking place. However, I take exception to your assertion that we were warned this was a possibility.

I would like to remind the Subcommittee members that *anything* is possible. Some things are probable. This is what is. And my agency, as it always has, will continue to deal with what is until it is no more.

Sincerely,

Dr. Leonard Church

Director of Project Freelancer

known as The Meta, it is the place where Agent Maine first went AWOL in search of more AIs and equipment. He began his ascension on the snowy peaks only to meet his demise at the bottom of their depths at the hands of the Blood Gulch troopers.

There are conflicting reports about whether or not Private Church traveled through time at this location.

ALTERNATE NAMES: Sidewinder, Longest, Avalanche

VALHALLA SIMULATION OUTPOST 17

>> *WE HAVEN'T BEEN THERE IN AGES. WHO KNOWS WHAT KIND OF NEFARIOUS NE'ER-DO-WELLS HAVE MOVED IN ON OUR TERRITORY?* <<

Simulation Outpost 17, also known as Valhalla, became the new home for the Reds and Blues while they unearthed the secrets of Project Freelancer. After Blood Gulch, the Reds and Blues parted ways, having realized that their ongoing struggle was nothing more than an elaborate multicolored ruse. Fate brought them back together—out of one canyon and into another.

NOTABLE FEATURES: Unlike the bases at Blood Gulch, Outposts 17-A and 17-B are equipped with antigravity devices that can launch soldiers (and lots of other stuff, apparently) halfway across the canyon. And while the Red team may not be able to figure out how to capture a single flag, they did create a hologram chamber underneath 17-B. At present, the chamber seems to only be good for simulating the murder of an anonymous, holographic orange soldier.

IMPORTANT EVENTS: The Reds and Blues were first drawn to Valhalla when Tex and Omega's Pelican crash-landed in between the outpost's two bases. Omega, up to his old tricks, infected the Reds and Blues at 17-A and 17-B. These antics attracted a new enemy, one of the most dangerous military criminals on record: The Meta.

ALTERNATE NAMES: Valhalla, Ragnarok

DELTA The opening shot of *Season 6: Reconstruction* was created by shooting the same sequence multiple times, with players moving to a different quadrant of the screen each time. When all of the shots were layered together, this gave the appearance that dozens of soldiers were on-screen at once.

HIGH GROUND SIMULATION OUTPOST 48

>> *SEE, THIS IS A SECURE FACILITY. NOBODY IN, NOBODY OUT. SORRY, I GUESS YOU'LL HAVE TO COME BACK NEVER.* <<

Nestled in the cliffs, this forgotten structure might be a base or a prison, depending who you ask. Formerly a training ground for Freelancers to practice infiltration and extraction missions until Agent Delaware blew up its outer wall (and herself), the abandoned Simulation Outpost 48 has had only one occupant in recent years—the slightly deranged Private Church, whose solitary assignment lasted for fourteen months. Oddly enough, Church found this preferable to his old position at Blood Gulch.

Until Private Caboose arrived, bringing a Freelancer in tow.

NOTABLE FEATURES: An unfortunately placed wall is great for stopping grenades. At the front of the base stands a gigantic gate, rendered moot by an equally gigantic hole which leads right inside.

IMPORTANT EVENTS: In his desperation to track down The Meta (only because he believed it would lead him to Agent South, who betrayed and left him for dead), Agent Washington followed a distress beacon back to High Ground. After an encounter with the AI-thirsty Meta, Washington killed Agent South in cold blood—with a much less cold flamethrower.

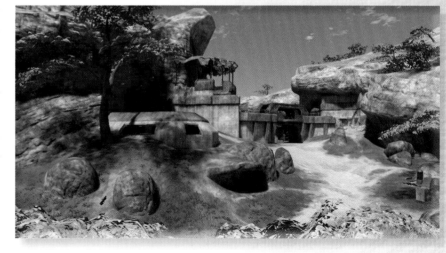

RAT'S NEST SIMULATION OUTPOST 25

>> *IF YOU FIND YOURSELF IN DANGER, OR IF YOU'RE IN A SITUATION WHERE YOU THINK SOMETHING BAD IS GOING TO HAPPEN, I WANT YOU TO REMEMBER JUST ONE THING. NEVER . . . EVER . . . COME BACK HERE.* <<

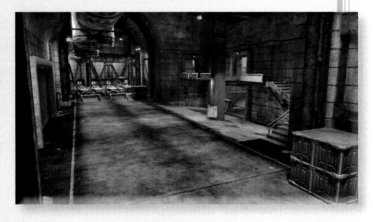

The outpost at Rat's Nest served as a secondary motorpool for Freelancer Command, specializing in vehicles. The Red and Blue bases stationed at Rat's Nest each have access to a number of Warthogs and Mongooses, as well as a circuit track, making this facility a suitable candidate for Freelancers to sharpen their driving skills. Agent Alabama in particular enjoyed hunting simulation troopers from the back of a Mongoose until he drove right over the edge of one of the cliffs.

NOTABLE FEATURES: Blue base's brig is not exactly Caboose-proof. A circuit track connects the two bases, perfect for vehicle combat or the occasional game of *Red vs. Blue* Chicken.

IMPORTANT EVENTS: Most of the troops reassigned from Blood Gulch Simulation Outpost 1 were sent to Rat's Nest. Here, their worth as soldiers was evaluated rather quickly—Agent Washington found Caboose tied up in the brig while Sarge stumbled upon Grif and Simmons facing down an execution by firing squad.

Prior to his arrest and execution sentence, Grif served as the sergeant of the Reds at Rat's Nest. His tenure as the leader of the Red outpost is one of the shortest and laziest on military record.

DELTA Once a year, Reds and Blues stationed at Rat's Nest still pay tribute to Agent Alabama by sending a flaming Mongoose soaring into the night sky. They watch the Mongoose explode on the rocks below with tears glistening in their visors.

THE EVIL LAIRS

Even evil needs a place to rest its head at the end of the day. Ranging from tropical fortresses to the cavernous depths of Caboose's brain, the evil lairs are the most diabolical locations in the war between Red and Blue. Where else are villains supposed to build robot armies, stockpile D batteries, and dream up a universe swallowed whole by oblivion?

THE POWER STATION

>> *YES, THIS PLACE WILL DO NICELY FOR AN EVIL LAIR. IT'S DIABOLICALLY DESIGNED!* <<

With an impassable wall at its rear and a beachhead up front, the power station offers the promise of an impenetrable fortress to the would-be villains of the galaxy. Maybe it's the high stone walls that create an impending sense of doom. Perhaps it's the electrical turbines within the station itself, charged with malaise. Or maybe bad guys just enjoy making prudent real estate investments. Either way, this place is irresistible to psychopaths and monsters alike.

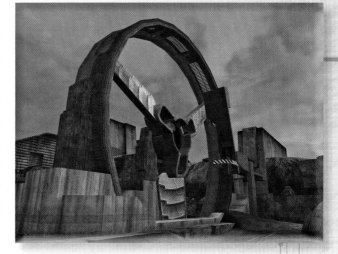

NOTABLE FEATURES: The giant windmill that helps power the station is constructed with razor sharp blades of death, ideal for keeping particularly slow, out-of-shape attackers from storm-

DELTA One of Church's few successful Sniper Rifle shots (and the only one he hit during *Season 6: Reconstruction*) occurred when he bounced a bullet off several surfaces at the power station to finally hit the escaping Meta in the leg.

DELTA Doc and O'Malley had to go $5,000 above asking price to finally land the evil lair of their dreams.

ing the base. The windmill also served as the resting place for Tucker's alien artifact, which launched him and Caboose into the Sacred Quest.

IMPORTANT EVENTS: Many shocking events happened at the power station that changed the course of the Blood Gulch simulation. First, it was the launchpad for O'Malley's dastardly schemes, which resulted in a daylong siege by the slowest-moving robots in history. Later, the Reds and Blues discovered that Gary, the computer program inside the base, was the missing Project Freelancer AI. Years after that, the Reds and Blues reunited at the power station in the middle of a fight against The Meta, who used the station to recharge his equipment.

ALTERNATE NAMES: Zanzibar, Last Resort

CABOOSE'S MIND

›› *THIS PLACE IS A WHOLE LOT BIGGER THAN I THOUGHT IT WOULD BE.* ‹‹

The most harrowing location the Blood Gulch troopers ever dared to tread, Caboose's mind brought a different sort of menace than what you'd typically find in an evil lair (like a moat filled with laser-eyed sharks). The AI Omega made Caboose's mind its playpen on a number of occasions while attempting to take over the universe. But deep within its cavernous expanses lies something more terrifying than the rogue intelligence hell-bent on enslaving the galaxy to its will—the Reds and Blues, as Caboose perceives them.

NOTABLE FEATURES: The most notable feature of Caboose's mind is a *who*, not a what. Here, Caboose is the all-knowing lord of a realm of idiots such as Pirate Sarge, Girl Donut, Yellow Griff (with two *f*s), and the exceedingly foulmouthed Leonard.

IMPORTANT EVENTS: Caboose's Mind was Church and Tex's hunting ground for Omega, who made Caboose his first host after years of riding shotgun with Tex. The second time Church and Tex infiltrated Caboose's mind concluded with Tex making a deal with Omega to end the war once and for all. The final time that Church visited Caboose's mind, however, was to seek out the remnant of the AI known as Delta, who left an ominous, fateful message: Memory is the key.

ALTERNATE NAMES: Hang 'em High, Tombstone

DELTA Leonard, the foulmouthed alter-ego of Church that dwells within Caboose's mind, was inspired by fan requests that the show bring back some of the vulgarity seen in earlier episodes of the series.

THE ISLAND FORTRESS

>> SHE LOST SOMETHING. I THINK SHE JUST NEEDS SOME TIME TO TRY AND FIND IT AGAIN. <<

Somewhere along the coast, an ancient alien monolith cuts an imposing line across a sunset sky. The brief home of both O'Malley and Wyoming, the island fortress offers a brief respite in the midst of evil plans, and a place to recharge on the water while creating new doomsday devices. What it lacks in answering machines, it makes up for in defensibility, as experienced by several Freelancers who attempted to scale its walls.

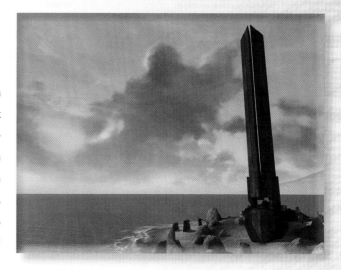

 DELTA Putting Carolina on location at the Island Fortress in Season 10 was no simple feat. Elements from both *Halo 2* and *Halo 3* were required to make her appear in the scene.

NOTABLE FEATURES: Due to its remote location, the island fortress only has access to dial-up Internet and fax.

IMPORTANT EVENTS: While the island fortress typically serves as an evil base of operations, it is more recently associated with Agent York of Project Freelancer. During an encounter with Wyoming, Agent York was shot and killed, leaving behind the Delta AI. Agent Washington later returned to the island fortress to retrieve the lost AI unit, only to have another run-in with Wyoming.

ALTERNATE NAME: Relic

THE GREAT PLAINS OF BLARGANTHIA

>> *THE BURNING PLAINS ARE NEXT TO THE FREEZING PLAINS? I BET THERE'S SOME PRETTY WET PLAINS IN BETWEEN.* <<

During the Blood Gulch simulation, the Blues were pulled into a religious prophecy that involved traversing a number of dangerous locations and completing arduous tasks. Like any epic journey, the Great Sacred Quest ended with someone getting pregnant.

THE GREAT BURNING PLAINS OF HONKA HILL

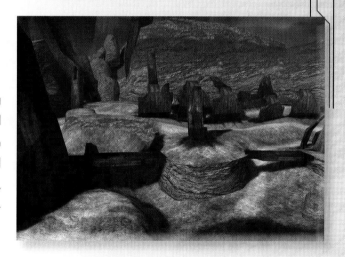

The Reds and Blues first visited The Great Burning Plains when they were mysteriously transported into the "future" by a bomb that detonated on Sidewinder. When Caboose and Tucker visited The Great Burning Plains for the Sacred Quest, they were charged with killing a ferocious monster, which turned out to be a cow.

THE GREAT SWAMP

During the Sacred Quest, the party took a night to recover at the Great Swamp. It is during this time that Tucker was impregnated by Crunchbite. The less said about this process, the better.

THE GREAT FREEZING PLAINS

The Sacred Quest to save an alien civilization eventually led Tucker, Caboose, Tex, Andy, and Crunchbite to the Great Freezing Plains. A converted simulation outpost, the base at the Freezing Plains of Blarganthia was manned by both Reds and Blues, who formed an uneasy alliance under the direction of the evil, time-twisting Wyoming.

Crunchbite died shortly upon arrival at the base, gunned down while stealing an alien ship.

NOTE: Alien ships are not immune to Rocket Launchers.

ALTERNATE NAMES: Burial Mounds, Backwash, Containment

PROJECT FREELANCER

For the Reds and Blues of Blood Gulch, all roads eventually lead back to Project Freelancer, the covert organization that treads on the lives of its soldiers in order to put a stop to the Great War. Shrouded in mystery and heavily fortified, not much is known about all of the locations and facilities of Project Freelancer, where secrets are revealed, history erased, and old loves brought back to life.

 DELTA The CAPTCHA window on the main computer inside of the Communications Bunker asks Simmons to enter the words "Hot Mess" to prove he is a human.

COMMAND

>> WE'RE GOING HOME. WE'RE GOING TO COMMAND. <<

Freelancer Command is a supposedly unassailable facility successfully infiltrated by a platoon of idiots. Twice. Above ground, Command is patrolled by guards armed to the teeth. Below ground, its labyrinthine depths are teeming with classified information best left forgotten. But that never stops the Reds and Blues of Blood Gulch, does it?

AI CONTAINMENT FACILITY

In a major breach of protocol, Agent Washington took Church to the AI Containment Facility beneath Command to reveal Church's identity as the Alpha.

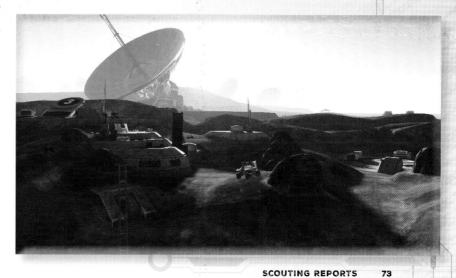

After being told by Washington that he is the Alpha, Church responded in the only way an expensive, government-created, smart AI is capable: "You're a fucking idiot."

DELTA In many interior shots in the *Halo* 3 map Standoff, characters had to be lit with Mongoose headlights.

COMMUNICATIONS BUNKER

While waiting for Church and Washington to return from the AI Containment Facility, the Reds hacked, cracked, and downloaded information from Command's secure data-bases. Sarge then deleted the Blues in the ultimate keystroke of victory, one of the swift-est and most thorough victories in military history.

THE ARCHIVES

Distraught from losing Tex, Epsilon Church with-drew into an AI storage unit. The storage unit was later transferred to the archives section of Command. However, the Reds and Blues joined forces to fight their way to Epsilon in a valiant, sort-of-crazy rescue mission . . . helmed by the even crazier Agent Carolina.

EMP CONTROL ROOM

In a last-ditch effort to contain The Meta, Washington led Church to the EMP (pronounced "imp") control room. Church sacrificed himself to stop The Meta, distracting Maine long enough for the EMP to fry his equipment and AI.

DELTA When the memory of Delta warns Caboose not to let Epsilon "begin the cycle again" in Episode 6 of *Season 8: Revelation*, he is referring to Epsilon's future actions at the Freelancer Offsite Storage Facility. Epsilon, in re-creating Tex from his memories, begins the same cycle that the Director started during Project Freelancer.

FREELANCER OFFSITE STORAGE FACILITY

›› *THIS BUNKER HAS BEEN CONSTRUCTED TO GUARANTEE THE CONTINUED OPERATION OF OUR PROGRAM, IN THE EVENT OF A PRIMARY FACILITY LOSS.* ‹‹

The Freelancer Offsite Storage Facility is a secure bunker designated for the continuation of Project Freelancer in the event that Command is compromised or taken offline. The Director, ever the cautious man, wanted a backup system in case his experiments were suddenly cut off from funding.

Presided over by FILSS (Freelancer Integrated Logistics and Security System), this storage facility holds supplemental equipment, armor enhancements, and other forgotten relics of the top-secret Freelancer program. In addition, the bunker contains the massive index of Project Freelancer archives, such as all the data of the conflict between the Reds and [REDACTED]. In the most remote corner of the facility lies the Director's private laboratory, lined with dozens of Cryo Tubes

NOTABLE FEATURES: A computer terminal disguised as a tree grants approved visitors admittance into the secret facility. To be qualified, you simply need to be a Freelancer, or know how to shoot computers with Shotguns.

IMPORTANT EVENTS: After an encounter with Washington brought Epsilon's buried memories rushing back, Epsilon and Caboose went in search of the Freelancer Offsite Storage Facility. Inside, Epsilon not only gave himself a new body, but also resurrected Tex . . . who announced her presence by promptly kicking everyone's asses. And faces. And crotches.

The storage facility was also home to the Reds' and Blues' most emotional altercation, as they banded together in an outstanding display of teamwork to defeat a roomful of resurrected Tex bodies.

This site also serves as the final resting place of Dr. Leonard Church.

ALTERNATE NAMES: Ghost Town, Foundry, Cold Storage

MOTHER OF INVENTION, RT-636

>> MOTHER OF INVENTION, *WE'RE INBOUND.* <<

The *Mother of Invention* soared through hostile space as the mobile command center for the UNSC's most shadowy operation. This sturdy flagship was a repurposed Paris-class light frigate, recommissioned after the original ship fell in battle against the enemy. The Director was awarded the *MOI* when his Freelancer experiments began to show promise in the field. Part training ground, part laboratory, part dormitory, and all 4 million tons of ass-kicking spaceship, the Mother of Invention was the birthplace of the top-secret military organization that changed the lives of the Reds and Blues forever—Church and Tex most especially.

Much like the shadow op carried within its hull, the *Mother of Invention* excelled at operating in secrecy. However, the Director was clearly unafraid to flex his MAC cannons, as seen in numerous up-close-and-personal slugfests with enemy forces.

In the end, it wasn't an external battle that finally brought this massive ship careening to its fiery demise, but an internal one. When Agents Tex and York started an all-out assault from within the ship, the explosive showdown resulted in the crash-landing of the *Mother of Invention* on Sidewinder. Its remnants have since been repurposed as underground bunkers on the icy outpost—its original form obscured by years of unrelenting snowfall.

SHIP LAYOUT: The size of a small city, the *Mother of Invention* was made up of dozens of subsections, each one serving a different function of Project Freelancer. According to Agent Washington, there was even a sauna on one of the lower sublevels that he was unable to locate, even though Agents York and North repeatedly gave him conflicting directions on how to find it.

MESS HALL

Due to their extremely regimented schedules, the soldiers of Project Freelancer didn't get much in the way of recreation time, but the mess hall gave them brief opportunities to relax and share a meal together. However, a food fight "incident" on one occasion left CT and Wyoming bitter enemies for the duration of the project.

TRAINING CHAMBER

In the training room, Freelancers brushed up on hand-to-hand combat, tested out new equipment, and gave their AI units a chance to experience combat scenarios. High above, a leaderboard tracked their progress with cool, calculating precision.

DELTA *Mother of Invention*'s call sign, 636, is a reference to Rooster Teeth's former address in Austin, Texas.

CLASSROOM

AI theory, proper equipment procedures—the Freelancers learned everything they needed to know about being the perfect soldiers through their daily classes with the Counselor. But they weren't the only ones listening and learning...

BRIDGE

The Director surveyed Project Freelancer at the helm of the *Mother of Invention*. From this post, he sent the frigate on secret missions, monitored the progress of his soldiers, and kept a watchful eye on humanity.

CHARON PRIVATE SECURITY FORCES

The Charon Private Security Forces cut off Dr. Church's efforts at every opportunity. These "rebels" hid their operations in the galaxy's most remote, hard-to-monitor locations, and to this day it is still unknown how they were able to go to such great lengths to conceal such a large network of troops. Who was funding these secretive endeavors, providing them with advanced weaponry, spot-on intel, and fully defensible bases? The galaxy may never know.

DELTA The explosive that destroyed this research facility as the Freelancers made their escape was set by none other than Agent Texas.

BJØRNDAL CRYOGENICS RESEARCH FACILITY

As far as posts go, the Bjørndal Cryogenics Research Facility never saw too much action. This former oil refinery chilled by the bitter cold is where soldiers put in their time to shoot for an early retirement. Unfortunately for them, retirement came much earlier than expected, all thanks to Project Freelancer.

NOTABLE FEATURES: Key towers all over the facility made perfect sniper nests. A central platform was an ideal place to slaughter dozens of private security soldiers.

ALTERNATE CODENAME: Blackout

UNSC SCRAP METAL RECYCLING STATION

The UNSC Scrap Metal Recycling Station, also referred to as Bone Valley due to the many skeletons of former UNSC ships, disguised an enormous base used by Charon. When a UNSC ship is captured, certain protocols dictate that the commanding officer's absolute duty is to erase all traces of the ship's data. This keeps critical information—such as the location of humanity's most important strongholds—out of the hands of an ever-advancing enemy. But as Project Freelancer demonstrates, not everyone follows the rules.

Charon hoped to find just such a ship with critical alien data. Perhaps this data still existed, somewhere in the graveyard of frigates and cruisers . . .

DELTA During early production of the Freelancer action sequence, it was not uncommon for renders of the Jet Pack scene to feature a plunger on the end of Carolina's grappling hook.

LONGSHORE SHIPYARDS

After the events at the UNSC Scrap Metal Recycling Station, the Longshore Shipyards were all that stood between Dr. Church and his goals. The shipyard's original purpose was to ferry raw materials to the orbital space elevators surrounding the planet, where they would be sorted for transport to the farthest reaches of the war.

Of all the death-defying maneuvers attempted by the Freelancers, the free-fall drop right into the middle of the Longshore base ranked among their most impressive. The Freelancers used Delta's talent of calculation and cold hard logic to completely surprise Charon's forces, and steal a momentous victory.

DESERT TEMPLE

>> THEY THINK THERE'S SOME KIND OF ARTIFACT HERE. SOME MASSIVE WEAPON BUILT A LONG TIME AGO. <<

Sand swirls in the arid wind, its coarse grains working into the most uncomfortable places in the standard issue Red and Blue armor. Buried beneath this ancient alien structure lay a powerful artifact—which Caboose eventually converted into his best friend.

NOTABLE FEATURES: Sand, everywhere. A distinct lack of water, leading to easily dehydrated light-ish red soldiers. A minefield surrounds the temple—it is unknown whether the

DELTA The battle between the dig team and Tucker began here after a heated argument about whether or not someone could pick up chicks in the dig team's Elephant—and if so, how many chicks?

mines were placed there by the soldier who called himself CT, by the aliens who first placed the artifact there, or by someone else.

IMPORTANT EVENTS: Tucker originally traveled to the temple to act as an ambassador between humans and aliens. However, once he discovered a dig team at the site, led by the villainous CT, Tucker triggered the temple's defenses and hid within its impenetrable stone walls. There, he forestalled them for months while he waited for backup. Of course, when the Reds and Blues first heard the distress call, they did what any good soldiers and friends would do—they ignored it.

ALTERNATE NAME: Sandtrap

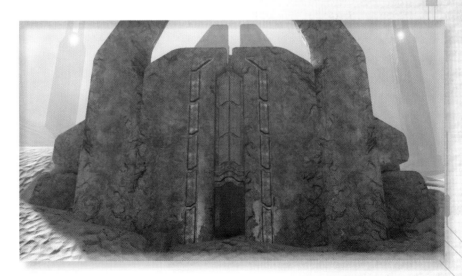

CHORUS

On the far reaches of colonized space, this remote planet has largely been left to its own devices—it even has its own form of government, established in the UNSC's absence. The New Republic upset the peace and attempted a bloody revolution to protest the government's "protection" of the people. Meanwhile, the Federal Army of Chorus fights to keep the peace—sometimes through brutal means.

The effects of the unforgiving war are felt all over Chorus, from its scorching deserts to its underground hideouts. For a time both sides waited patiently for the right moment—or perhaps the right soldiers—to help them seize victory.

Now, Chorus stands in unison against the space pirates. Have all their years of fighting prepared them for this moment, or left them depleted and low in morale?

CRASH SITE BRAVO

>> WE CRASHED IN THE MIDDLE OF NOWHERE, ON A PLANET IN THE MIDDLE OF NOWHERE. FUCKING BEAUTIFUL, EVERYBODY. <<

Ah, life after Project Freelancer. Finally, the Reds and Blues can relax, kick back a little, and enjoy a cushy new assignment, preferably one at an off-world resort or an intergalactic petting zoo. Well, not exactly. Mysterious circumstances may surround the crash that brought the

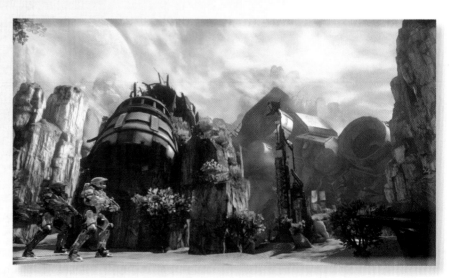

Blood Gulch crew to Chorus, but their home at Crash Site Bravo is all too familiar to them—it's another canyon in the middle of nowhere.

DELTA Many fans assumed Crash Site Bravo was a stand-in for Blood Gulch at the end of Season 10, but Season 11 revealed that the Reds and Blues crashed there shortly after taking down the Director.

The Blues make camp in the shadow of the transport that fell from the sky, which also happens to be loaded with experimental weaponry. Meanwhile, the Reds make camp out of . . . some sandbags. There are no radio signals. No signs of life. No Church and no Carolina.

So why do they always feel like they're being watched?

NOTABLE FEATURES: Besides the wreckage of a massive UNSC ship filled to the brim with lethal ordinance, there's not much of note about Crash Site Bravo. However, one of the bases does have an embarrassingly slow Internet connection, whose bandwidth is entirely occupied by something called "Basebook."

IMPORTANT EVENTS: After the arrival of the Reds and Blues to Chorus, word quickly spread to both the New Republic and the Federal Army of Chorus. Both armies wanted to get their hands on the troops who had squashed Project Freelancer—anyone who could pull that off had to be among the greatest fighters in the galaxy.

This misinformation led to a deadly confrontation between the Reds, the Blues, and both sides of the civil war. As a result, Simmons, Tucker, Grif, and Caboose escaped with the New Republic, while Sarge, Washington, Lopez, and Donut were captured by the Federal Army of Chorus.

DELTA Even though the ship was brought down by greedy space pirates, every one of the Blood Gulch gang has a reason to feel guilty about the ship crashing. Well, everyone except Caboose.

But of course, that's not the whole story. It never is.

ALTERNATE NAME: Exile

NEW REPUBLIC UNDERGROUND HQ

>> *THEY'RE REBELS! OF COURSE THEY LIVE IN A CAVE!*
IT'S HIDDEN. <<

Beneath the mountains of Chorus lies the dizzying network of tunnels that protect the New Republic Headquarters. From this, the biggest of their makeshift hideaways, the New Republic launches its operations, runs training exercises, and, most importantly, keeps out from under the thumb of the oppressive Federal Army of Chorus.

This isn't your plucky Hollywood rebellion.

Once teeming with soldiers, these dusty halls are now all but barren as the war has thinned the ranks of every side. All that remain are men and women with their heads hanging low from the weight of a planet's suffering—and many of them are barely even old enough to be considered adults. Here, morale scrapes the bottom of the barrel, and the bottom of the barrel is all that's left in terms of talent. Many in the New Republic wonder if there's any hope left.

Especially once the new captains arrive.

DELTA The popular reality TV series *Chorus Idol* had to run Season 17 from the main stage of the New Republic's base, as so few eligible contestants remained on the planet. Lt. Jensen took home the final prize.

NOTABLE FEATURES: Private Grif's favorite feature, the mess hall, often closes early from lack of rations. At the stage at the center of HQ, soldiers come together to hear the latest bad news from the war. The most notable fixture, however, is Kimball, surveying her army with barely suppressed worry.

IMPORTANT EVENTS: Tucker, Caboose, Grif, and Simmons were whisked away to the New Republic's underground base by the mercenary Felix after the battle at Crash Site Bravo. Separated from their friends, the four Reds and Blues only had a short time to whip their squads into shape to mount a rescue mission.

ALTERNATE NAME: Erosion

FEDERATION ARMY OF CHORUS OUTPOST 37

>> BREAKING IN WOULD BE SUICIDE, BREAKING SOMEONE OUT WOULD BE LIKE SUICIDE, PLUS A BUNCH OF PUPPIES DYING. <<

Isn't it supposed to be the rebels in the hidden snow base?

When the New Republic began their public displays of terror in the streets of Chorus, the Federal Army centralized their efforts. In order to protect innocent civilians from the New Republic's non-discriminatory attacks, a large

portion of Federal Army operations were relocated to a massive snow base away from major urban population centers. From here, the Federal Army attempted to regain control of the planet.

The base proved to be a blessing and a curse. An enormous, frozen wall helps keep the New Republic out, but also prevents the Federal Army from gaining back much ground. While casualties mount, they redouble their efforts with the help of General Doyle's knack for public speaking and Locus's knack for dishing out cold, hard punishment.

NOTABLE FEATURES: Federal Army Outpost 37 is one of the Feds' largest outposts, and is made up of several smaller subsections. Frozen tunnels connect the different components. One wing features a number of jail cells for holding war criminals, although Private Donut likes to spend his leisure time there in handcuffs. Dr. Grey's medical wing is home to a number of biological and technological experiments, some of which are too gruesome to name, let alone witness.

IMPORTANT EVENTS: In war, things aren't always what they seem. And rarely is anything definitively black or white. Although Tucker, Caboose, Grif, and Simmons thought their friends were captured by the Federal Army of Chorus, it turned out that wasn't the case at all. At the snow base, Washington, Donut, Lopez, and Sarge were given a different perspective on the war entirely.

When the Red and Blues reunited on the rescue operation, things got more than a little crazy. Felix betrayed the Reds and Blues as he and Locus revealed their plot. Agent Carolina saved the day with a surprise entrance. And the Reds and Blues found themselves in another ridiculous scenario—with bigger, more dramatic stakes than ever before.

ALTERNATE NAME: Longbow

ABANDONED FUEL STATION

>> IT'S A GAS STATION! THAT WE'VE BEEN TO BEFORE! SERIOUSLY, THERE'S LIKE THREE PLACES TO GO ON THIS PLANET. <<

An excellent supply source to both sides during trying times, this abandoned fuel station keeps the New Republic and the Feds well stocked at an exorbitant price. That is, until the owner catches word of the goings-on at Crash Site Bravo.

NOTABLE FEATURES: An old convenience store that's long been devoid of any signs of life beyond old war propaganda posters. A sleeping bag inside indicates the former owner might have been living here prior to his death.

IMPORTANT EVENTS: Locus visited the abandoned fuel station, so naturally there are bodies buried here. The New Republic Reds and Blues made this a pit stop on the way to the snow base, Federal Army Outpost 37. While here, they stumbled across the lethal, scary space pirates for the first time.

ALTERNATE NAME: Outcast

RADIO JAMMER STATION 1C

>> THOSE TWO MERCENARIES ARE THOROUGH. THEY'VE GOT SOME SORT OF RADIO JAMMERS SET UP THAT ONLY ALLOW BROADCASTING ON CERTAIN FREQUENCIES. <<

A retrofitted power plant manned by menacing space pirates. Radio towers, keeping the truth from ears that need to hear it most. Two opposing forces, bearing down on the Capital to end the war once and for all. And the Reds and Blues, the only soldiers who can keep everyone from killing each other.

Seems like the perfect place for a video confession.

NOTABLE FEATURES: Rolling seas and treacherous rock passes protect this station from invaders. Giant towers crackling with electricity assist the space pirates in blocking communications for the entire planet.

DELTA While Season 12 writer/director Miles Luna originally wanted to have this showdown take place in the Capital, the only suitable location was the twinkling city map of Skyline in *Halo 4*. However, unlike the other city maps in *Halo 4* (which is where the New Republic and Fed confrontation occurred), Skyline is a night map, which would have looked inconsistent with the rest of the sequence. Thus, Vertigo was selected for the climactic confrontation.

IMPORTANT EVENTS: The Reds and Blues attacked Radio Jammer Station 1C in order to stop the civil war on Chorus before it ruined the planet for good. Though Felix and Locus tried to offer them a chance to walk away from the conflict and save themselves, the Reds and Blues chose to stay and fight. They'd performed the rare selfless deed before, but only in service to one another—here, they risked their lives for complete strangers.

ALTERNATE NAME: Vertigo

Dear Director,

I want to thank you in advance for your openness in response to our subcommittee's request for more information.

We were disappointed that your Recovery force reported a total loss at Outpost 17-B. We had hoped there would be at least *one* soldier left who could shed some light on the situation. I know that your agency has enjoyed a high degree of freedom with very little scrutiny in the past few years.

It is not our intention to disrupt such a progressive military program, but instead to find a way we can work together, in a manner that befits all our responsibility. I am certain that you will agree. And we look forward to making this review process as painless as we possibly can.

Yours truly,

Malcolm Hargrove

Chairman of the Oversight Subcommittee

A response from the Director of Project Freelancer:

Dear Chairman,

While I am obligated to assist your investigation, I ask that you not waste my time with irrelevant questions. My agency is normally unconcerned with such minute directives as troop reassignment. Except of course in the most critical of matters.

Sincerely,

Dr. Leonard Church

Director of Project Freelancer

CRASH SITE ALPHA

>> *ALPHA'S ANOTHER STORY . . . FROM WHAT WE'VE GATHERED, IT'S A MASSIVE HOTSPOT FOR PIRATE ACTIVITY. I'D UNDERSTAND IF YOU DON'T WANT TO JOIN US.* <<

Crash Site Alpha is home to the other half of the *Hand of Merope*, the UNSC ship that plummeted through the skies of Chorus carrying the Reds and Blues. Teeming with space pirates and sparking wreckage, it's hazardous to step foot in this valley. However, it's even more dangerous to leave the planet, due to the towering tractor beam that can rip ships right from the sky.

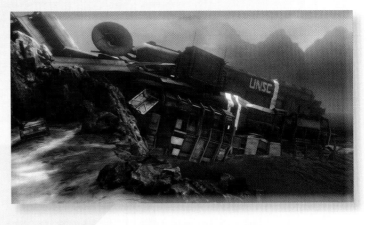

NOTABLE FEATURES: The space pirates use the giant alien tractor beams at Crash Site Alpha to bring down ships passing near

DELTA The ship that brought the Reds and Blues to Chorus is named the *Hand of Merope*. In Greek Mythology, Merope was one of the daughters of Atlas. Her mother, Pleione, is famous for being the protector of sailors. In this case, the sailors just happened to be the protectors of Chorus.

Chorus's atmosphere; plunder from the ships helped fund the civil war for years. And yes, this tractor beam is the real reason the Reds' and Blues' ship crashed, as opposed to spilling sodas, unplugging cables, updating browsers, or flirting with pilots.

IMPORTANT EVENTS: The Blue team snuck into Crash Site Alpha to nab the *Hand of Merope*'s flight manifest, hoping to find a clue to the origins of the mysterious space pirate force that was puppeteering the civil war on Chorus. While they didn't find what they were looking for, they did learn an important lesson about trust.

This site was also home to one of the biggest, most deadly battles in the conflict over Chorus. The allied New Republic and Feds tried to stage a final attack on the space pirates in an attempt to bring the tractor beam tower down and send a ship out of orbit to call for help. However, a trap was sprung and Charon reinforcements arrived, resulting in staggering casualties. Fortunately, Simmons had a few tricks up his sleeve, which allowed the Chorusans to escape and Sarge to pull the slow-motion Warthog assault he'd always dreamed of.

Later, the Reds and Blues used the tractor beam to bring the *Tartarus* crashing onto Locus, Felix, and the Purge Tower.

ALTERNATE NAMES: Wreckage, Meltdown

ARMONIA, CAPITAL CITY OF CHORUS

>> AS WE SPEAK, THE ARMIES OF CHORUS ARE CONVERGING ON THE CAPITAL. THE BATTLE THAT ENSUES WILL LEAVE NO SURVIVORS. IF YOUR GOAL WAS TO SAVE THESE PEOPLE, YOU HAVE FAILED. <<

The once strong beating heart of an entire planet, the Capital of Chorus is now just a staging ground for its two armies. The effects of the war can be seen everywhere—an abandoned car on a street corner, a city park dotted with litter, Jensen crashing a vehicle into what used to be a civic landmark...

As tension mounts between the temporarily peaceful allies, both New Republic and Fed soldiers wonder when the other shoe is going to drop. It's only a matter of time before the space pirates come to find them where they live.

NOTABLE FEATURES: Nothing special, just a barren city full of empty high rises. The city limits provide ample space to sit, reflect, or wallow. Public transportation offers a great set-piece for epic grudge matches between old enemies.

IMPORTANT EVENTS: Armonia was supposed to be the final, bloody battlefield for the Chorus Civil War, as staged by Felix and Locus. Had everything gone according to plan, the armies would have slaughtered each other, and any straggling survivors would have been executed by the cloaked space pirates presiding over the battle.

However, once the Reds and Blues slipped a message through to the city, exposing Locus and Felix's planned betrayal, the generals declared a temporary cease-fire. Doyle and Kimball's continued hatred of each other threatened to tear the alliance apart, until the attack on the

city by the space pirates brought out levels of heroism neither general expected. The city both had fought so hard to protect was laid to waste by an overloaded reactor. It's not known what, if anything, survived the blast.

ALTERNATE NAMES: Landfall, Perdition, Complex, Harvest

CHARON RESEARCH COMPLEX

›› THIS COMPOUND ISN'T ONE OF CHARON'S TYPICAL MUNITIONS FACTORIES OR RADIO JAMMERS. THEY'RE NOT DISASSEMBLING ALIEN ARTIFACTS HERE, THEY'RE TRYING TO TURN THEM BACK ON. ‹‹

Looking for some alien gadgetry? Join the club.

The Charon Research Complex is home to many of Charon's experiments in Freelancer equipment and alien studies. It's also a staging ground for a nearby excavation site. There seem to be fairly interesting readouts coming from the alien structure located there . . .

Perhaps it requires closer study.

NOTABLE FEATURES: Multiple research facilities at this complex house weapons, equipment, and records of tests conducted in the field. Don't expect to find any funnel cake stands near the alien tower, though—Charon doesn't understand the value of nostalgia like Chorusans do.

IMPORTANT EVENTS: Led by Carolina and Epsilon, the Reds and Blues captured the Charon Research Complex in order to even the odds against Charon, who constantly had the Chorusans outgunned. From the complex, Dr. Emily Grey launched an expedition to The Temple of Arms.

ALTERNATE NAME: Complex

THE ALIEN STRUCTURES

>> YOU'RE TELLING ME PEOPLE ON THIS PLANET ARE JUST USED TO SEEING FLYING SPACE SHIT LIKE THAT? <<

The UNSC may have forgotten about Chorus, but the planet was of primary importance to the aliens of the distant past. While the aliens left their legacy scattered throughout the galaxy, it was on the planet Chorus that they chose to house many of their finest treasures. Dispersed through various temples across and beneath the planet's surface, these treasures could prove to be the very thing that saves Chorus . . . or destroys it.

TEMPLE OF ARMS

Beneath the Charon Excavation Site lies the Temple of Arms, a storehouse of powerful combat vehicles, weaponry, and a myriad of other technological marvels from a time long past. Tucker activates the Temple of Arms accidentally with his sword, which turns out to be a key (and not just the kind that unlocks someone's death when you stab them).

JUNGLE TEMPLE

The Jungle Temple not only serves as a temporary base for Charon, it also houses a portal to another "dimension." There, only true warriors with clarity of mind can withstand the horrors of their past. The reward? An ancient alien AI who knows all the secrets of Chorus.

TEMPLE OF THE KEY

High up in the snowy mountains of Chorus rests another mysterious alien temple. The key inside gives its bearer the ability to open any temple on Chorus (and seriously, there's a ton of them). One of the snowy caverns just might hold an old friend who's totally been gone for a while even though nobody noticed.

COMMUNICATION TEMPLE

The communication temple allows those who are worthy to send a message to virtually any communication device in the galaxy. It's here that the Reds and Blues engage in their final showdown with Charon in an attempt to radio Earth for help.

PURGE TOWER

With great power comes great responsibility, and sometimes more power ... like the kind that can wipe out all sentient life on the planet. To prevent their technology from falling into the wrong hands, the aliens set up the Purge Tower as an incredibly lethal failsafe.

Carolina and Wash race Felix and Locus to this location, and engage the two mercenaries in combat. However, the Freelancers weren't trying to defeat their opponents—they were merely stalling them long enough for the others to bring one of Charon's warships crashing down. The impact destroyed the Purge Tower, and any ability it had to kill all of the inhabitants of Chorus.

ALTERNATE NAMES: Meltdown, Vortex, Haven, Solace, Ravine, Monolith

VITAL STATISTICS

>>>>>>>>>>>>>>>>>>>>>>>>>

War is hell . . . but simulated war is hilarity.

Deep in the annals of Project Freelancer's simulation program, mathematicians and Chief Science Officers have pooled their brainpower to understand the madness of the Red and Blue armies of Blood Gulch. Numbers have been crunched. Statistics have been tabulated. Charts have been graphed.

What follows is a breakdown of twelve grueling, often comical campaigns. Within these vital statistics, you'll find every piece of data on *Red* vs. *Blue* you've ever wanted to know—and in some cases, way, way, way, way more than you've ever wanted to know.

NOTE: Due to conflicting reports from the final days of the war on Chorus, we have not been able to procure statistics from the Reds' and Blues' 13th campaign.

NOT-SO-FRIENDLY FIRE

Red vs. Blue is a game of numbers. And we've got a tally of all the violence, carnage, robot homicide, and (sort of) accidental team-killing to prove it.

Grenades Thrown: 110

Most Thrown in One Season: Season 11: 26

Best Arm: Donut (7 grenade kills)

Tank Shots Fired: 82

Targets Locked: 11

Most Shell-Shocked Episode: Season 1, Episode 9

Robots Murdered: 112
Never Forget: Robot massacre of Season 10
(99 robots killed)

Warthogs Destroyed: 30
Biggest Insurance Bill: *Season 6: Reconstruction*
(11 Warthogs lost to explosion, The Meta, and EMPs)

Collateral Damage: 87 innocent UNSC soldiers killed
during the Simulation and Project Freelancer years
Safest Seasons to Be on UNSC Payroll: 2 and 5

Church's Overall Sniper Rifle Accuracy: 9.3%
Worst: Season 3 (0% with 10 shots fired)
Best: Season 5 (100% with 2 shots fired)

Flags Grabbed: 6
Most Grabs: Red Team

Nut Shots: 14
Numbest Nuts: Grif took 7 shots to the balls in *Season 8: Revelation*, Episode 10

"Ghost" Possessions: 28
Biggest Haunter: Omega, Season 5 (Possessed Simmons, Doc, Grif, Sarge, Tex, Church,
Caboose, Donut)

Ammo Forgotten: 4 times

Surrenders Negotiated: 5

Eulogies Given: 5

DELTA The hissing sound of the plasma
grenade was performed by Burnie Burns
for the majority of *The Blood Gulch
Chronicles.*

Picking Up Chatter

The familiar radio signal that plays whenever someone contacts Command can be heard in fifty-two episodes of *Red vs. Blue*.

Someone Fix That Wall

The 4th wall of *Red vs. Blue* has been demolished a total of twenty-two times throughout the series. This structure was obliterated to its greatest extent in Season 11, when it was breached on seven separate occasions.

Dear Director,

Due to your busy schedule we have begun interviewing members of your staff. I'm certain you will let us know if this bothers you. Our debriefings keep coming back to a single subject at Outpost 17-B. Can you explain to us what this "Meta" is and what your plans are to deal with it?

Yours truly,

Malcolm Hargrove

Chairman of the Oversight Subcommittee

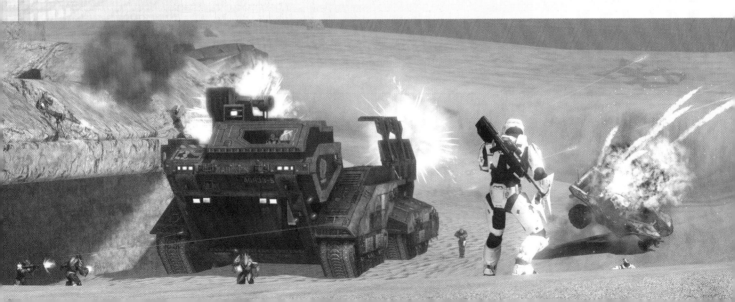

SOLDIERS OF POP

They may not know their weaponry, equipment, or much of anything military-related at all, but the Reds and Blues sure do know their pop culture references. From '50s music to classical literature, these soldiers can out-reference the best.

NUMBER OF POP CULTURE REFERENCES

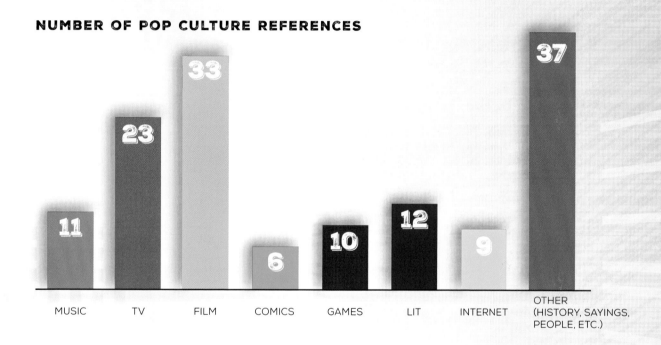

| MUSIC | TV | FILM | COMICS | GAMES | LIT | INTERNET | OTHER (HISTORY, SAYINGS, PEOPLE, ETC.) |

Most Referenced Movie: *The Matrix*, *Star Wars* (*Star Wars* accounted for roughly 36 percent of Season 12's references.)

Most Referenced TV Show: *Lost* (often angrily)

Most Referenced Literary: *Frankenstein*

Biggest Reference Dropper: Sarge (who happens to love old music)

Most References: Season 11, Episode 6

CHATTER CHART

Red vs. Blue's soldiers are known for their colorful catchphrases as much as they are for their personalities. Audio logs have given us better insight into the popular sayings of Blood Gulch.

	SIMMONS SUCKING UP	SHUT UP, CABOOSE!	BOW CHICKA BOW WOW	COCKBITE	SHOTGUN!	SUCK IT!	DIRTBAG	SON OF A BITCH!
SEASON 1	3	9	0	3	1	0	0	14
SEASON 2	6	3	0	3	0	3	5	3
SEASON 3	15	3	0	0	1	0	3	3
SEASON 4	6	2	8	0	1	3	3	1
OUT OF MIND	0	0	0	0	0	0	0	0
SEASON 5	15	5	3*	0	1	3	0	1
RECOVERY ONE	0	0	0	0	0	0	0	0
SEASON 6: RECONSTRUCTION	5	5	1	0	2	3	0	0
RELOCATED	2	0	0	0	0	1	1	1
SEASON 7: RECREATION	4	5	1	0	0	1	0	2
SEASON 8: REVELATION	1	2	1	0	0	0	1	2
SEASON 9	3	4	0	0	0	0	1	4
SEASON 10	3	4	5	1	2	1	1	0
SEASON 11	4	6	2	0	1	0	0	4
SEASON 12	0	2	1	0	0	2	6	0

*To be fair, one of these was a "*bow chicka honk honk,*" and one was a "*hey chicka bump bump.*"

Pedal Pushers

There seems to be confusion about the number of pedals on regulation UNSC vehicles. The Reds and Blues have commented on this design hiccup on five separate occasions.

Donut Entendres: 32 accidental sexual innuendos
Private Donut often finds himself in an orgy of misunderstanding.

Alien Lingo

Crunchbite delivered thirty-five "blarghs" and five "honks" in Season 4.

Brownnosing

Simmons did his biggest stint of brownnosing during Season 2's finale, "K.I.T.B.F.F."

KILL COUNT

The Reds and Blues are fairly acquainted with the taste of bitter defeat. But that never stops them from dishing out some sweet, ass-kicking justice.

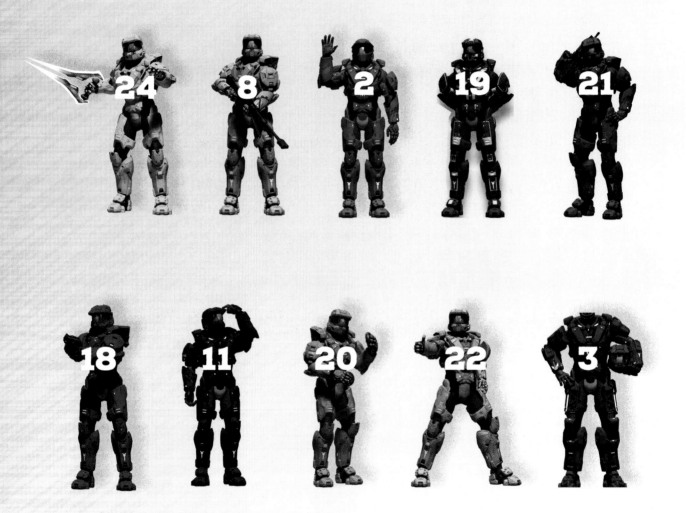

Note: Church's and Caboose's team kills are counting against them.

Grif, the Dead Man

Sarge has threatened or wished for Grif's death on fifty-six separate occasions.

Donut, the Tease

Donut has nearly become another casualty in this brutal simulated war multiple times, with five near-death incidents.

Switching Teams

Carolina added four kills of her own when helping the Reds and Blues against the space pirates in Season 12.

Peaceful Matters

Seasons 2 and 9 had the lowest kill counts of the entire series. In Season 9, this was due to the action being contained within Epsilon's mind. In Season 2, the Reds and Blues mostly used their words (and sometimes, Spanish love ballads) to tear each other down.

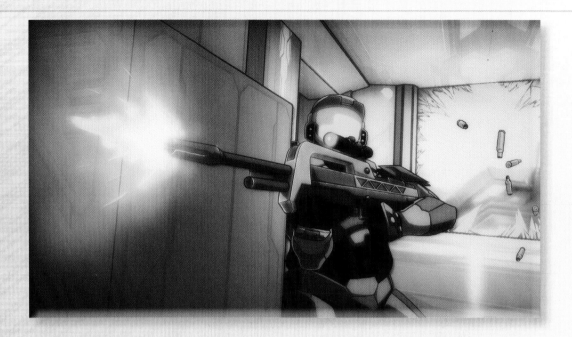

Freelancer Flashback Kills

	SOUTH	NORTH	CAROLINA	TEX	YORK	WASH	CT	MAINE	WYOMING
SEASON 9	23	23	12	6		4		1	
SEASON 10	2	7	68	27	1	8		3	

Kill Stealing

Surprisingly enough, neither Agent Wyoming nor CT registered any kills during the Free-lancer flashback sequences in Seasons 9 and 10. However, Carolina and Tex more than made up for any of their deficiencies on the field.

DELTA During Season 10, Episode 18, "Change of Plans," the Reds and Blues argue about which team has the higher score. At this point in the series, the Blues actually lead by a single kill, accounting for Wash's kills and Church/Caboose's team kills, respectively. The score: Reds 19, Blues 20.

THE DEFINITIVE RED VS. BLUE TIMELINE

With more than ten seasons under its belt, *Red vs. Blue* weaves a complex tale of bitching and bickering across the past, present, and future. For the first time, analysts have been able to piece together the series of events that brought about this epic, decade-spanning conflict.

Note: This relative timeline focuses on the most important moment of the Red and Blue war—when Alpha arrived at Blood Gulch. Information has been parsed from the destroyed case files in the Freelancer Offsite Storage Facility. Not necessarily infallible.

BEFORE BLOOD GULCH (B.B.G.)

29 B.B.G.—29 YEARS BEFORE BLOOD GULCH

> Agent Carolina born.

23 B.B.G.—23 YEARS BEFORE BLOOD GULCH

> Allison Church dies in the Great War.

17 B.B.G.—17 YEARS BEFORE BLOOD GULCH

> Leonard Church receives doctorate in AI theory.

7 B.B.G.—7 YEARS BEFORE BLOOD GULCH

> Dr. Leonard Church's Project Freelancer is cleared for funding.

> Project Freelancer receives a single AI, designated Alpha.
> Project Freelancer attempts to find an ideal soldier to pair with Alpha. Fifty new recruits are selected and field-tested. Not many survived.

BETA. The Alpha spontaneously creates a standalone, sustainable by-product. This fragment, designated Beta, is cleared for active duty under the codename Agent Texas.

> Dr. Church applies for more AI units and is denied. He is told that AIs are extremely valuable assets—each one in the field presents an incredible security risk.

4 B.B.G.—4 YEARS BEFORE BLOOD GULCH

> Intel stolen by Agents North and South points Project Freelancer to the Sarcophagus.
> Inspired by the generation of Beta and working with his project's Counselor, Dr. Church devises a way to engineer fragments of Alpha by reverse-engineering a personality disorder. All attempts fail.
> Two Freelancer teams steal the Sarcophagus, destroying part of a city in the process.

3 B.B.G.—3 YEARS BEFORE BLOOD GULCH

> The Sarcophagus's alien contents are used to harvest Delta.
> Agent Carolina offers her AI to Agent Maine, who has lost the ability to speak.
> UNSC Oversight Subcommittee formed, Malcolm Hargrove named Chairman after his predecessor is forced to resign in a political scandal instigated by an anonymous source.
> Project Freelancer ramps up production of its AI units.

2 B.B.G.—2 YEARS BEFORE BLOOD GULCH

> CT defects from Project Freelancer.
> Agent Washington is implanted with the Epsilon AI. The AI attempts to kill itself in Agent Washington's mind, severely damaging his mental state.

THE BREAKOUT. Agent Texas leads an attack to free the Alpha, who is so fragmented he no longer recognizes her. The *Mother of Invention* crashes on Sidewinder in the fallout. Agent Maine uses these events to try and obtain new AI. He, Carolina, and Texas all go MIA.

> UNSC Oversight Subcommittee approves simulation outposts for Project Freelancer.

1 B.B.G—1 YEAR BEFORE BLOOD GULCH

> The state of Florida sinks into the ocean.
> The Gamma AI forcibly removes itself from Agent Wyoming and goes into hiding.

> Simulation outposts are built all over the galaxy.
> Agent York leaves Project Freelancer.

AFTER BLOOD GULCH (A.B.G.)

0 A.B.G.—THE YEAR OF ALPHA'S ARRIVAL AT BLOOD GULCH

> Alpha is moved to Blood Gulch under the name Church. He is placed in the care of the jovial Captain Butch Flowers, formerly Agent Florida of Project Freelancer.
> The Reds arrive at Blood Gulch, forcing a stalemate that will last for years.
> Captain Butch Flowers dies of an aspirin overdose, leaving Church to assume command.
> Red Base is sent a kit to build an autonomous suit of armor (normally used to house standalone AIs) to mask that Blue base has been sent one for Alpha.
> Church is killed by the rookie Caboose.
> Freelancer Texas arrives at Blood Gulch.

> Texas is killed by the Red rookie Donut. The Omega AI goes missing.
> Agent Washington is cleared for active duty and assigned to locate and acquire missing Project Freelancer assets under the new designation Recovery One.

> Medical Officer DuFresne arrives at Blood Gulch to assist both teams.
> Private Tucker overhears a transmission between the Reds and VIC. Command conscripts Wyoming to assassinate Tucker.
> Private Tucker is impregnated with the first human-alien baby.

RECOVERY ONE. After York is killed in battle against Wyoming, Agent Washington retrieves his AI, Delta. An enemy later designated as The Meta attacks North, South, and Washington to collect AIs. Washington is betrayed and left for dead.

> Motivated by their experience with the Sarcophagus, Omega and Wyoming kidnap Tucker's alien baby, believing he holds enormous power. Agent Texas agrees to join them.
> Agent Wyoming is killed, and Agent Texas and Omega are once again MIA.

THE GREAT WAR ENDS. Troopers from Blood Gulch outpost are reassigned after the catastrophic end to their simulation.

> Private Tucker and his son, Junior, become ambassadors for human-alien relations.

2 A.B.G.–2 YEARS AFTER ALPHA'S ARRIVAL AT BLOOD GULCH

> A Pelican crash-lands at Outpost 17, Valhalla.
> The Meta ransacks Valhalla in search of Texas and Omega.
> The UNSC Oversight Subcommittee investigates Dr. Leonard Church.
> Agent Washington is once again cleared for active duty in order to hunt The Meta. He makes contact with the Reds and Blues from Blood Gulch outpost.
> Agent South is killed. Official reports state that she is another victim of The Meta.
> A soldier calling himself CT lays siege to an ancient alien temple.
> The Blues are deleted from Command's databases.

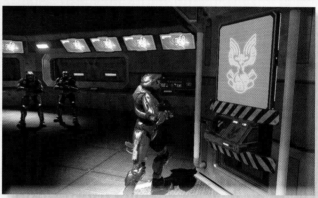

> Project Freelancer's crimes are exposed by Agent Washington, who is imprisoned for aiding in the destruction of valuable UNSC property.
> The Alpha is erased by an EMP at Command.
> Dr. Leonard Church is brought to justice for war crimes by Malcolm Hargrove.

3 A.B.G.–3 YEARS AFTER ALPHA'S ARRIVAL AT BLOOD GULCH

> Agent Washington is cleared for duty to hunt the Epsilon AI unit, along with The Meta.

RESURRECTION. Caboose installs the failing Epsilon in an ancient alien artifact. Epsilon leads Caboose to a remote facility, where he is reborn as Church and creates another version of Tex from his memories.

> Agent Texas and Epsilon infiltrate Sidewinder, where both are retrieved by Agent Washington.
> Agent Maine and Agent Washington are KIA. The new mysterious leader of Blue Team reports that Washington died heroically in battle.
> The failing Epsilon capture pod is logged into the UNSC Archives for storage.
> The UNSC receives strange reports from Chorus, but ignores them due to the aftermath of recent Freelancer events.

4 A.B.G.—4 YEARS AFTER ALPHA'S ARRIVAL AT BLOOD GULCH

> Agent Carolina tracks down the Reds and Blues.

5 A.B.G.—5 YEARS AFTER ALPHA'S ARRIVAL AT BLOOD GULCH

> Agent Carolina infiltrates the UNSC Archives.
> The Director returns to the Freelancer Offsite Storage Facility.
> Carolina leads an attack on the facility. The Director takes all of its systems offline and erases all data before taking his own life.

CHORUS. Contact is lost with the *Hand of Merope* somewhere near Chorus.

> Private Simmons creates Basebook.
> A ceasefire is called between the Federal Army of Chorus and the New Republic.
> The UNSC prison ship *Tartarus* is boarded by space pirates.
> Alien weapons burn out on Chorus and across the galaxy.
> The *Staff of Charon* is spotted in Chorus airspace.

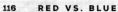

Dear Chairman,

Rest assured we have the situation under control. While The Meta is proving to be an elusive enemy, our Recovery agent is already closing in on it. I expect this incident will reach a conclusion soon, and I will be able to return to my research. Hopefully without further interruption.

Sincerely,

Dr. Leonard Church

Director of Project Freelancer

Dear Director,

We can all understand that the shift from autonomy to oversight can be a difficult adjustment for anyone, but especially someone of your standing. In that spirit, we have attempted to accommodate your *brief* explanations to our serious inquiries. Nonetheless, I feel compelled to inform you that even *our* trust has its limits.

Yours truly,

Malcolm Hargrove

Chairman of the Oversight Subcommittee

BLOOD GULCH MISSION BOOK

Brilliant military strategies require brilliant military minds. Unfortunately, the Reds and Blues have never had either of these. Many of their plans end in catastrophic failure or Donut's death, depending on who's initiating the plan. Here is a compilation of some of their more harebrained schemes, some of which never even made it off the ground—and many that made it much too far for their own good.

THE PLAN TO SAVE TEX FROM THE REDS (SEASON 1, EPISODE 14)

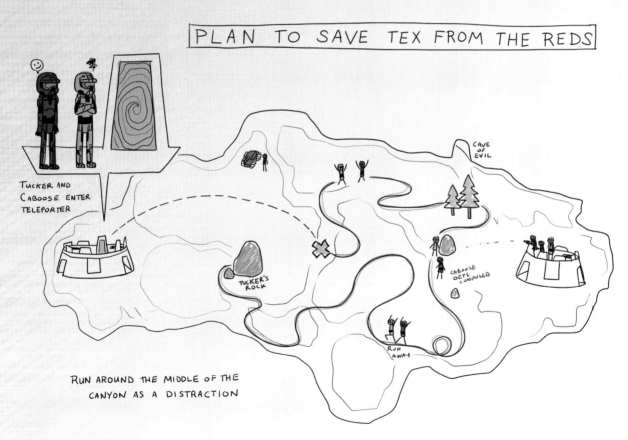

PLAN TO SAVE TEX FROM THE REDS

TUCKER AND CABOOSE ENTER TELEPORTER

CAVE OF EVIL

TUCKER'S ROCK

CABOOSE GETS CONFUSED

RUN AWAY

RUN AROUND THE MIDDLE OF THE CANYON AS A DISTRACTION

CHURCH POSSESSES
VARIOUS REDS

AND SPRINGS TEX
FROM RED BASE

CABOOSE WILL
SHOOT SARGE

AND MAKE CHURCH
HIS NEW BEST FRIEND

TUCKER'S PLAN TO GET THE REDS TO TURN OFF THEIR RADIOS (SEASON 2, EPISODES 12–14)

① LOPEZ SERENADES SHEILA

② REDS TURN OFF THEIR RADIOS

③ HOSE OFF LOPEZ AND SHEILA BACK AT BASE

OPERATION: TROJAN BOMB

(SEASON 2, EPISODES 18–19)

PUT 10 MEGATON BOMBS IN EACH OF THE ROBOTS

YOU'RE NOT MY REAL DAD!

FRANCISCO MONTAGUE ZANZIBAR

ROBOT #2

THEN WE USE SIMMONS'S ROBOT PARTS TO FAX IN AN AIRSTRIKE

SARGE'S PLAN TO RESCUE DONUT FROM THE PELICAN

(SEASON 5, EPISODE 1)

MISSION: RESCUE DONUT
"HULK OUT"

LOCATE RADIATION

GET ANGRY

USE INNER RAGE TO LIFT SHIP

MISSION: BASE SWAP (SEASON 5, EPISODE 18)

 MISSION: BASE SWAP!

OBJECTIVE: CAPTURE BLUE BASE WHILE THEY CAPTURE RED BASE

APPROACH BASE IN ADVANCED COVER-FIRE FORMATION

LIGHT GRIF ON FIRE

HEY!

FLANK HIM WHILE HE SCREAMS

DONUT BOMBARDS BASE WITH GRENADES
(YEARS OF TOSSING MAKES HIM SUITABLE FOR THIS TASK)

IN EVENT OF CAPTURE: DONUT KILLS EVERYONE WITH GRENADES

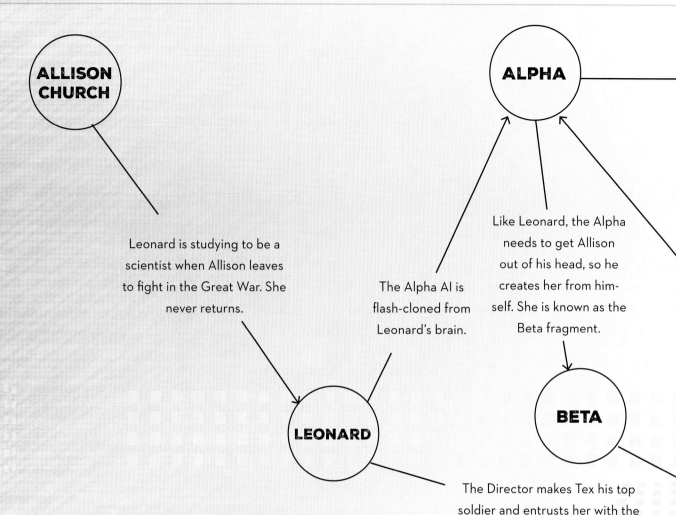

ALLISON CHURCH

Leonard is studying to be a scientist when Allison leaves to fight in the Great War. She never returns.

LEONARD

ALPHA

The Alpha AI is flash-cloned from Leonard's brain.

Like Leonard, the Alpha needs to get Allison out of his head, so he creates her from himself. She is known as the Beta fragment.

BETA

The Director makes Tex his top soldier and entrusts her with the Omega AI and a suit of armor to protect her.

RECURSION ROMANCE:
THE MANY ITERATIONS OF
CHURCH AND TEX

How many times have Leonard and Allison repeated the cycle of love, loss, and resurrection? Let us count the ways.

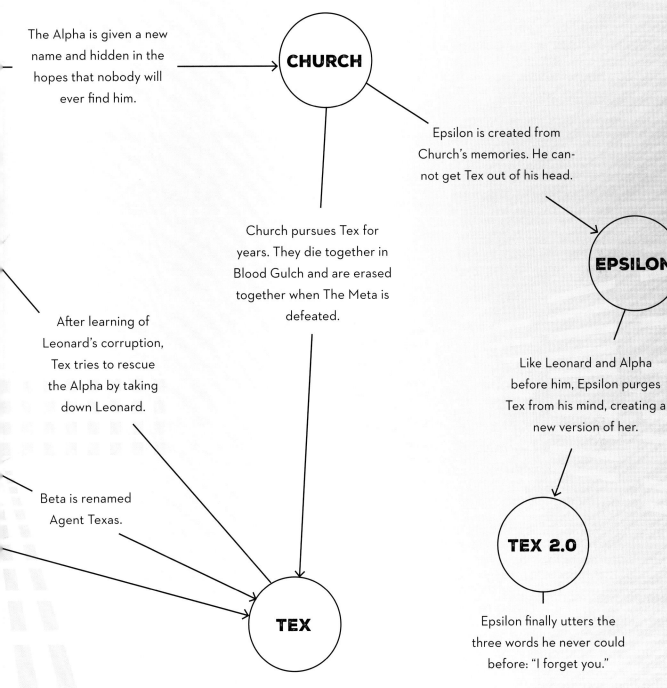

The Alpha is given a new name and hidden in the hopes that nobody will ever find him.

CHURCH

Epsilon is created from Church's memories. He cannot get Tex out of his head.

Church pursues Tex for years. They die together in Blood Gulch and are erased together when The Meta is defeated.

EPSILON

After learning of Leonard's corruption, Tex tries to rescue the Alpha by taking down Leonard.

Like Leonard and Alpha before him, Epsilon purges Tex from his mind, creating a new version of her.

Beta is renamed Agent Texas.

TEX

TEX 2.0

Epsilon finally utters the three words he never could before: "I forget you."

Dear Chairman,

The Meta is *nothing* more than an entity seeking to increase its power in these confusing days after the war. From my perspective, that seems to be a very common occurrence at the moment.

Sincerely,

Dr. Leonard Church

Director of Project Freelancer

SIMULATION ARCHIVES

>>>>>>>>>>>>>>>>>>>>>

In the last thirteen years, the Reds and Blues have unraveled government conspiracies, destroyed millions of dollars of military equipment, witnessed dozens of massacres, and witnessed the conception of the first alien-human baby. Countless resources have been devoted to not only cleaning up in the aftermath of Blood Gulch Simulation Outpost 1, but also keeping it quiet. Within these archives are portions of documents and data collected on the Reds and Blues.

You never know when they might come in handy.

HOW TO BUILD A ROBOT BY SARGE

Document discovered in a buried metal box outside of Valhalla Outpost 17-A, following a series of bizarre and rather involved challenges. Journal was covered in what appeared to be powdered sugar.

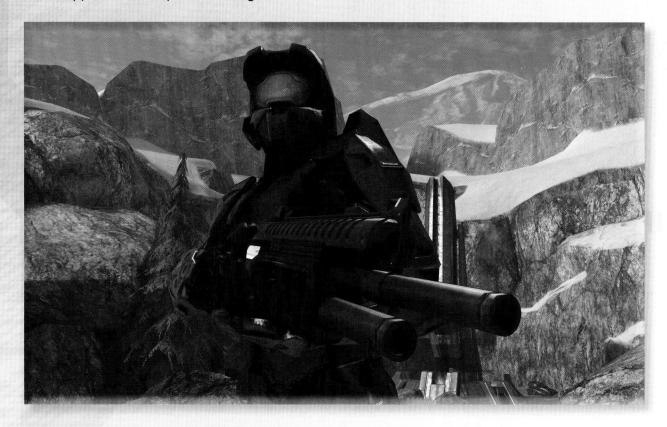

Hello, dirtbags!

If you've been able to find my super-secret robot manual, you're either the most conniving, diabolical Blue around, or your name is Dick Simmons. That's the only explanation for how you

DELTA Many of Sarge's popular catchphrases are improvised by voice actor and director Matt Hullum on the spot.

managed to get your hands on my well-illustrated treasure map, then followed the incredibly specific instructions, answered a slew of brain-bending trivia questions about the many ways I wish Grif to die, and finally guessed the secret word that opens my mysterious lockbox!

But now you're here. A good Sergeant knows when he's been beaten...

... Except that I haven't been, because these pages have been laced with a specially procured Blue poison, perfect for killing Blues! So you might as well read, on the eve of your imminent demise. Go on, sip a strawberry Yoo-hoo® while you wait for the end.

What follows is my collective research on robotics. My Manifesto Roboto, if you will.

Alas, the fruit of my labors will only be seen by you, lone dirtbag. If only I'd had a better way to record my findings than this Hello Kitty® journal I confiscated from Private Donut's knapsack. A theft I'd rather not discuss—the things I saw in that knapsack are never to be spoken of again.

Perhaps I could have documented my knowledge of robots in a more permanent medium. Like an electronic typewriter. Or one of them planes that writes messages in the sky. Although maybe that wouldn't have worked, since we all know the sky is part of a Blue conspiracy to spread their dirty colors all over the galaxy!

But I digress. I could talk about Blues until I'm some unmentionable color in the face!

Time to get to the robots.

SARGE'S LAWS OF ROBOTICS

1) ROBOTS SMELL WEAKNESS

Rearing your mechanical pup requires a firm, Red hand. Don't be afraid to let your robot know who's boss. Never admit faults, even in the cold face of logic. Your robot will respect you for it. Maybe even grow to love you.

2) ROBOTS NEED STRUCTURE

The robot's natural place in the chain of command is at the bottom, where it can be strapped with even more chains! The extra chains will keep the robot firmly rooted in its subservient role to you, its master. Your programmable pal might need reminding of this every time its bytes get too big for its britches. Use derogatory remarks like "dirtbot," "metal mouth," and "steel nuts" to reestablish the proper mechanical pecking order.

I see zero ways for this to backfire.

3) ROBOTS REQUIRE TASKS

Robots love to put their extensive processing power and high-tech gadgetry to the simple duties we meat sacks perform every day. The more menial, the better!

Done with your food? Use your robot's gas-powered jaws as your personal garbage disposal. Have him (or her, if you're in Japan) brush your teeth, hold your goblet during meals, or warm your socks with its heat sync. Robots are enamored with the mundane parts of ordinary life. They're just chomping at the bit to be part of our world.

ROBOT-AT-A-GLANCE

CABEZA

> Where the thinking bits go
> Optic sensors calibrated to target Blue/Orange soldiers
> Home of the mythical English speech unit
> Gas-powered jaw
> Sarcasm cortex
> Store secret plans here

ARMS

> Strong hands for kung-fu death grips and holding wrenches
> Capable of 2-ton carrying capacity, or roughly 1 Private Grif

TORSO

> Jumbo-sized cup holder in rear
> Empty cavity perfect size for storing bombs
> Well built for father/son hugging moments
> Center of emotional programming
> 17 USB ports around nipples
> Mini-disc player
> Advanced polymer gut gives spooky premonitions

FEET

> Robots love playing *futbol*!

PELVIC ZONE

> Ass crack doubles as fax machine
> Front side dongle switch for self-maintenance and emergency override (it's not very big)

LEGS

> Built for marching to its master's orders, possibly crushing things underfoot
> Titanium alloy knees are well tempered for subservience
> Prize-winning robot thighs. 1st place at State!

TIPS BEFORE YOU BEGIN ASSEMBLY

- Find your robot kit instructions and make 'em skedaddle! Instructions are just another Blue attempt at brainwashing and conformity!
- Always have spare robot nuts on hand—you would not believe how quickly these things disappear.
- Learn Spanish. Or at the very least, Spanish-sounding words. Trust me on this.
- If you plan to upgrade, it's much easier to do it while you're building the robot than trying to add more parts later. Construct your weather machines, 10-megaton bombs, missile payloads, poisonous gas, and giant lobster pincers as early as possible!

PARTS NEEDED

- Lube (preferably scented)
- CPU with activation code (I recommend "activation code")
- Motor oil, 5 gallons
- 1 UNSC robot kit with karate chop action
- 1,237 screws of varying lengths
- Robot nuts
- Robot-building music
- Baking soda, 1 cup
- Sugar, 17 Tbsp
- 942 C batteries
- HTML 27 handbook
- Mad scientist goggles
- Copper rectum

Dear Director,

Your program was granted the use of a single artificial intelligence unit for implantation experiments. Yet the department records clearly show multiple agents in the field with implants during the same time frames. Surely this must be a logging error, and we anticipate a corrected document soon.

Yours truly,

Malcolm Hargrove

Chairman of the Oversight Subcommittee

Dear Chairman,

I understand your concern that increased activity would bring increased risk. However, our fail-safes are simple but foolproof. A dead or dying agent's beacon automatically notifies our recovery team, and we will be on the scene immediately to secure all the military's property.

Sincerely,

Dr. Leonard Church

Director of Project Freelancer

WASHED HANDS

Project Freelancer audio log 03221A-G, 0907. Psych evaluation of Corporal David ███████, *prior to designation as Agent Washington.*

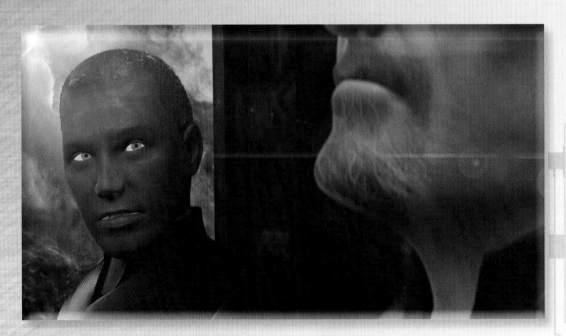

COUNSELOR: Ah, Corporal ███████ You are late. Please have a seat.

███████: Sorry, sir.

(Sounds of chair moving.)

███████: I had a car thing. Me and cars don't get along.

COUNSELOR: How unfortunate for you, David. May I call you David?

███████ : Sure . . . sir. Do I call you sir? All I know is your code name.

COUNSELOR: You may continue referring to me as Counselor.

███████ : Hmph. I'm not used to all these secrets.

COUNSELOR: Do secrets make you uncomfortable, David?

███████ : I just prefer transparency. I like to know what I'm getting into.

COUNSELOR: Well, if you are admitted into the Project, then I am sure we will get to know one another very well.

███████ : Aren't you the psych doctor? In that case, I hope we don't.

(Nervous laughter.)

COUNSELOR: Let's get started then, shall we?

(Rustling papers.)

COUNSELOR: How are you, David?

███████ : Is that a trick question?

COUNSELOR: There are no trick questions.

(Pause.)

███████ : I'm super.

(Writing.)

███████ : You're writing down an awful lot there.

COUNSELOR: Just my observations. Does this evaluation make you . . . anxious?

███████ : Let's just say being psychoanalyzed doesn't top my list of hobbies.

COUNSELOR: Why would you say that is?

███████ : I don't like people trying to look around inside my head.

COUNSELOR: What if a mission required it?

███████ : I said I don't like it, not that I won't do it.

COUNSELOR: That is good, David. Why do you want to join the Project?

███████ : I've seen the status reports from the War. The lists of casualties. I can read between the lines. We're losing, aren't we?

COUNSELOR: The UNSC's official position—

███████ : I know the official position, Counselor. Is it true?

COUNSELOR: I would prefer not to comment on speculation.

███████████: I *speculate* that you just answered my question for me.

COUNSELOR: What if I told you there was a man, David? A man with an idea that might tip the balance of the Great War back to humanity's side.

███████████: Is that what this Project Freelancer thing is about? An idea?

COUNSELOR: Ensuring the survival of mankind in a harsh and hostile galaxy. Enabling our soldiers to go to greater lengths than we ever thought possible.

███████████: And what do my *feelings* have to do with being a better soldier?

COUNSELOR: Let's just say a soldier's mind is of critical importance to Project Freelancer.

(A chair creaks.)

███████████: OK. I'm interested.

COUNSELOR: Tell me about your service record, David.

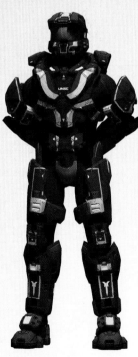

███████████: Nothing you don't already know from my file. Basic training in the Leonis Minoris system before . . . well, you know what happened there. Bounced around to different systems. Patrol duties, stuff like that.

(Pause. ███████████ hesitates.)

COUNSELOR: And then the alien attack at your last post?

███████████: Yeah. That.

COUNSELOR: Your file speaks of an incident. You had a . . . disagreement with the Staff Sergeant?

███████████: He wanted to send everyone to their deaths. I disagreed.

COUNSELOR: You disobeyed orders?

███████████: I saved a platoon.

COUNSELOR: You injured a commanding officer.

███████████: Yeah, Command thought that was the more important part of the story, too.

COUNSELOR: Would you say

you still harbor strong feelings of resentment about this incident?

████████: OK, that's got to be a trick question. Yes. Of course I do.

COUNSELOR: Thank you for your honesty, David. Honesty is good. Would you say you hold a grudge against this commanding officer?

████████: Grudge is one word for it. My mom used to tell her friends about the fights I had with my sisters. "That boy can hold a grudge better than any gossip I've ever known. He's got such a . . ." What did she call it? Such a . . .

(Snapping fingers.)

████████: A long memory. Look at that, you've got me talking about repressed memories now.

COUNSELOR: That is interesting. Thank you for sharing.

(Rustling papers.)

COUNSELOR: There is one more incident I would like to discuss with you. Can we talk about Cecil Kyle?

████████: Wait. Are you serious?

COUNSELOR: You recognize the name?

████████: Well, yeah, the kid was in my fifth-grade class, but—

COUNSELOR: Is there something wrong, David?

(████████ takes a deep breath.)

████████: How do you even know about this?

COUNSELOR: His parents never pressed charges, did they?

(Rustling papers.)

COUNSELOR: Cecil Kyle was found in the boys' restroom with major head trauma. He nearly lost vision in one eye.

████████: Counselor—

COUNSELOR: "When asked about his involvement, David ████████ said that Cecil Kyle had bullied him in the second grade three years prior. Kyle resumed his antics in the bathroom before David defended himself . . . rather excessively." That is the statement we have.

(Pause.)

████████: That was a long time ago.

COUNSELOR: And yet you have very strong feelings about the memory.

Would you like to talk about them?

█████: No. I'd really rather not.

(A chair pushes away from the table.)

COUNSELOR: It wasn't self-defense, was it, David? What you did to Cecil Kyle?

█████: Is that what your file says?

COUNSELOR: I am just asking you a question. Was what you did to Cecil Kyle self-defense?

(█████ sits back down.)

█████: No. I . . .

(Pause.)

COUNSELOR: Take your time, Corporal.

█████: I hated him so much. He used to sit behind me on the tram to school and flick my ears, say things about my family. Sometimes he'd do more than just talk. So . . . yeah. I was behind him in the bathroom three years later. He asked me what I was looking at, and then I put his face through the mirror.

COUNSELOR: I am sensing a pattern in your actions here, David.

█████: No no no no, this isn't a pattern. That was years ago. It has nothing to do with what happened at my last post.

COUNSELOR: I believe that our honesty today has been very productive. Which is why I believe we should drop the pretenses. You did not volunteer for this Project solely to help win the war. You are volunteering because you have fallen out of favor with the UNSC. Courts-martial typically do not end in the kind of assignments suited to a man of your considerable talents. You are here because you have no other options. Already this incident with Cecil Kyle has been re-added to your personnel files in light of recent behavior.

█████: Wait, what?

COUNSELOR: There will be nothing left for you in the UNSC, Corporal.

█████: Why are you telling me this?

DELTA When we first meet Agent Washington, his new designation is Recovery One. Hidden from Washington was the fact that Agent South was Recovery Two.

COUNSELOR: Do you remember that man I mentioned earlier?

███████: Yes. The one with the idea.

COUNSELOR: He wants to give you a second chance. To help you expunge this data from your records and serve humanity. And he is the only one willing to do so.

(███████ laughs bitterly.)

███████: Tell me where to sign, Counselor.

[Audio Redacted]

COUNSELOR: We will be in touch, David.

███████: I look forward to it.

(███████ leaves the room. Another door opens.)

COUNSELOR: I am not sure he can be trusted, Director.

DIRECTOR CHURCH: And why is that, Counselor?

COUNSELOR: He disobeyed direct orders. He has a history of a violent temper, repressed anger, a long—

DIRECTOR CHURCH: And we have shown him mercy.

He'll be loyal to us for that. We'll give him everything that everyone else took away.

(Pause.)

COUNSELOR: As you say, Director.

DIRECTOR CHURCH: Good. Now if you'll come with me, we are having some problems with Alpha.

COUNSELOR: Problems, sir?

DIRECTOR CHURCH: He seems distracted. Something he can't quite get out of his head.

COUNSELOR: Something, or someone?

DIRECTOR CHURCH: Shut up, Counselor. And turn that recorder off.

[Audio ends.]

LOGGING ACTIVITY
022.03.815.9398

STATION SIX
CAMERA 448-5

WEST HALLWAY ACTIVITY:
AUTHORIZED ESCORT TYPE 2

PLANS B, C, AND D

Retrieved from the UNSC Wind Power Facility shortly after the collapse of the simulation project at Blood Gulch Outpost 1. Inside, detailed schematics created by the former AI entity Omega, representing his alternate plans to take over the universe. It is difficult to make sense of, but it seems that the journal was written by two argumentative individuals—or perhaps one extremely crazy person.

PLAN B: ~~THE CYCLE OF GREENNESS~~ LANDFILL CONTINUUM

1) CREATE TIME MACHINE

BACKSTAB WYOMING

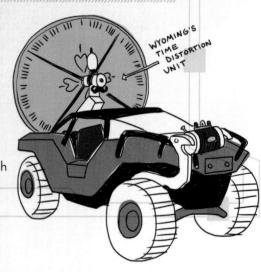

WYOMING'S TIME DISTORTION UNIT

BRILLIANT! EVERY GREAT PLAN STARTS WITH A DIABOLICAL DOUBLE-CROSSING.

What if we *front* stabbed him instead? Seems more honorable. Or better yet, we can serve him a nice brunch and ask for what we need diplomatically.

SHUT UP!

STEAL WYOMING'S TIME DISTORTION UNIT

THIS MAY REQUIRE KILLING. OR TORTURE. OR BOTH!

MODIFY TIME DISTORTION UNIT INTO TIME MACHINE

LOPEZ'S BRAIN CAN HANDLE THE CALCULATIONS. I'LL HAVE TO CONVERT THE NUMBERS TO SPANISH.

While we're waiting, Lopez can tell us about his heritage and culture.

NOBODY CARES ABOUT LOPEZ'S CULTURE.

Yo soy El TIEMPO MECANICO

2) GATHER THE UNIVERSE'S TRASH

LOCATE ALL TRASH FACILITIES

← START WITH DOC, LOL

WE'LL PROBABLY HAVE TO BREAK INTO A GOVERNMENT FACILITY AND KILL INNOCENTS!

Actually, a simple Google search can pull up all public waste facilities. That's how I found all of our secret lair's reupholstered furniture!

STEAL TRASH

OR POSE AS UNSC GARBAGE MEN AND COLLECT IT OURSELVES. EITHER WAY, WE MAY NEED TO HIRE HENCHMEN.

Great! We'll be performing a valuable service and creating jobs to boost the local economy.

WE'LL ALSO HAVE TO STOP RECYCLING.

Gasp!

SEND TRASH TO THE PAST

~~Won't that just make our present junkier?~~

DELTA In Season 4's brief glimpse of O'Malley's secret base at the Island Fortress, we hear a telephone ringing. This telephone sound was the same telephone used at the Rooster Teeth offices, leading to quite a bit of confusion during production about whether or not the phone in the office was actually ringing or not.

SEND TRASH TO THE FUTURE

MY, THE FUTURE SMELLS QUITE PUNGENT! MUHAHAHAHA!

Are we going to work together in a spirit of temporal cooperation, benefiting from the future's superior renewable technology?

NO! WE'RE GOING TO PISS THEM OFF!

PREPARE FOR WAR

READY DEFENSES FOR INEVITABLE RETALIATION FROM THE FUTURE.

CAPTURE FUTURE SOLDIERS AND STEAL SUPERIOR WEAPONRY

LASER BEAMS! DEATH RAYS! OBLIVION GUNS! ALL OF IT WILL BE OURS!

How are we going to capture them with inferior technology?

DAMMIT

PLAN C: THE TROJAN COOKIE

1) CREATE DELICIOUS, IRRESISTIBLE COOKIE RECIPE

GATHER RECIPES

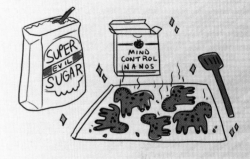

STEAL COOKBOOKS FROM THE BLACK MARKET! OR BUY THEM ON AMAZON.

I prefer to support authors at local bookstores.

I PREFER TO SUPPORT THEM WITH DEATH!

PRICE OUT BULK BAKED GOODS

IS THERE A SPECIFIC BRAND OF SUGAR THAT CAUSES SUPER DIABETES?

Alternatively, I know of a lot of baking blogs with fantastic tips for gluten-free, sugar-free cookies! Cut down on calories and introduce cookie lovers everywhere to healthier snack foods!

BAKE!

USE OUR EVIL CHEMISTRY SET TO CREATE THE MOST FLAVORFUL DOOMSDAY TREAT THE GALAXY HAS EVER KNOWN!

INSERT MIND CONTROL NANOMACHINES

BORROW FROM OUR FRIENDS AT APPLE. THEY OWE ME ONE.

BUILD AN ARMY ... OF DOOR-TO-DOOR COOKIE SALESMEN!

NOBODY WILL SUSPECT DEATH TO COME IN SUCH A SWEET PACKAGE!

Proceeds from cookie sales can support local animal adoption centers, too.

POCKET THE CASH

:(

2) ACTIVATE MIND CONTROL SIGNAL

THOSE FAT FOOLS EVERYWHERE WILL TASTE OBLIVION FIRSTHAND, ONLY THIS TIME IT WILL TASTE LIKE CHOCOLATE CHIPS! WHICH ARE DELICIOUS.

I'm not sure the FDA will approve nanomachines in cookies. Also, I doubt our secret lab is going to pass inspection. What kind of ingredients are we going to use? People are more health conscious now than ever! I recommend organic ingredients and non-GMO additives.

WHAT ABOUT MSG?

I think we need to go back to the drawing board. I've got this Banana Bread recipe that—

NO

PLAN D: OLD-FASHIONED THEME PARK TYCOON

1) CREATE AMAZING THEME PARK CONCEPT

BRAINSTORM SUPER-FUN RIDES

STEAL IDEAS FROM THEME PARKS ALL OVER THE UNIVERSE! EVEN THAT ALIEN ONE WITH THE WEIRD RIDE THAT SPRAYS VOMIT ON YOU.

A multicultural destination of fun!

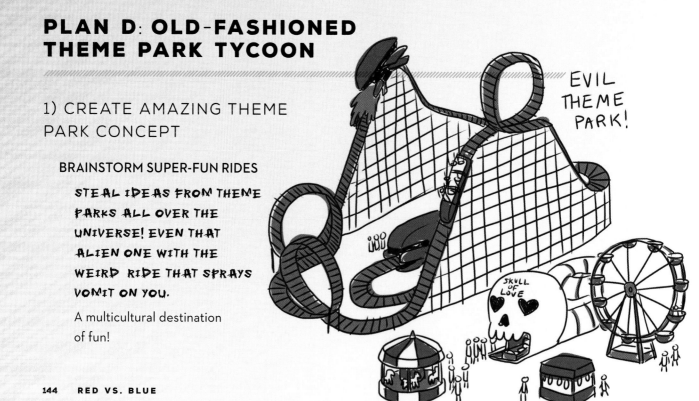

EVIL THEME PARK!

SKULL OF LOVE

WE'LL NEED ROLLER COASTERS, MULTI-MEDIA EXPERIENCES, AND A TUNNEL OF LOVE!

Let me guess: the tunnel of love is a tunnel of death?

FIND A SUITABLE LOCATION

BLOOD GULCH WOULD BE PERFECT FOR OUR THEME PARK. MAYBE THOSE RED AND BLUE IDIOTS WILL BE CRUSHED WHEN WE LEVEL THE CANYON!

2) COURT INVESTORS

WOO INVESTORS FOR MONEY

I'LL NEED A SUIT FOR THIS. SOMETHING SNAZZY AND DEBONAIR.

Does the lapel spray poison gas?

EVEN WORSE! AXE BODY SPRAY!

3) SELL OUT

BUILD THEME PARKS IN EVERY MAJOR SYSTEM

MILLIONS WILL FLOCK TO OUR SPECTACLES! PAY FOR OUR TRAMS! TAKE HOME STUFFED ANIMALS AND STAY IN OUR OVERPRICED RESORTS!

And then we'll, what? Blow it up? I'm not seeing the evil part of this plan yet.

BLOW IT UP? WHILE THEY'RE ENJOYING THE ODST DROP OF TERROR? YOU MONSTER!

SELL PARK TO FACEBOOK

WE'LL BE BILLIONAIRES!

4) UNLEASH GIANT GORILLAPUS!

USE OUR MONEY FOR THIS BLASPHEMOUS YET BEAUTIFUL CREATION, CAPABLE OF DESTROYING THE GALAXY. IT'S PART GORILLA. PART OCTOPUS. ALL EVIL.

OK, that's more like it.

Dear Director,

I feel you're avoiding the question. If this target was already in possession of an AI unit, how was he able to secure an additional unit from Agent South? Would not that verify, as we indicated earlier, that your program now runs experiments with more than one artificial intelligence? If so, where did these additional AI come from? And more importantly, how did your agency procure them?

Yours truly,

Malcolm Hargrove

Chairman of the Oversight Subcommittee

DONUT'S SUPER-SECRET DIARY

>>>>>>>>>>>>>>>>>>>>>>>>>>

Private Donut's written record of everything that transpired at Blood Gulch Simulation Outpost 1 was found in the deepest, darkest hole in the canyon. His writings cast an illuminating light on the events of the project. Even though his version doesn't quite match up with the other troopers' accounts of their time at Blood Gulch, it's the closest we have to firsthand knowledge of the simulation.

We've pulled out the more meaningful entries. There was an awful lot of poetry and recipes to sift through. We would like to emphasize "awful."

ENTRY 1: **DAY 1 AT BLOOD GULCH**

DEAR SUPER-SECRET DIARY,

TODAY WAS MY FIRST DAY ON THE JOB AT BLOOD GULCH. THE GUYS AT COMMAND WEREN'T KIDDING. IT REALLY IS JUST A BOX CANYON IN THE MIDDLE OF NOWHERE. I'VE NEVER BEEN FOND OF BOXES, SO I HAD MY DOUBTS, BUT MY FIRST DAY WENT WELL.

THE RED GUYS TRIED TO RAZZ ME—YOU KNOW, LIKE GUYS DO—AND EVEN SENT ME

TO THE STORE FOR SOME TOTALLY MADE-UP ELBOW GREASE. WELL IT TURNS OUT I DIDN'T GO TO THE STORE AT ALL, BUT BLUE BASE! AND THROUGH A SERIES OF COINCIDENCES I DON'T THINK I SHOULD DISCLOSE BECAUSE THEY DON'T MAKE ME SEEM AS COOL, I CAME BACK WITH THE FLAG!

IMAGINE HOW I FELT, SKIPPING THROUGH THE GRASS WHILE WHITE-HOT BULLETS SPRAYED AROUND ME, HOLDING THAT POLE IN MY HANDS. I FELT ALIVE. FREE. LIKE I'M FINALLY WHERE I WAS MEANT TO BE.

THE GUYS LET ME ERECT IT RIGHT IN THE MIDDLE OF THE BASE. LET ME TELL YOU, IT WON'T BE THE LAST TIME THEY'LL SEE OL' DONUT'S FLAG POLE. NO SIR.

ENTRY 4: **DAY 7 AT BLOOD GULCH**

DEAR SUPER-SECRET DIARY,

I'M SO EXCITED!

AFTER I GOT BLUE TEAM'S FLAG, COMMAND DECIDED TO GIVE ME MY OWN COLOR ARMOR. I PICKED THE MOST PERFECT SHADE OF LIGHT-ISH RED TO FULLY COMPLEMENT THE REST OF THE GANG. IT'S BEEN LOOKING WAY TOO AUTUMN AROUND HERE.

NEW ARMOR COMES IN TOMORROW! SQUEE! I CAN'T WAIT TO SHOW THE GUYS.

ENTRY 5: **DAY 8 AT BLOOD GULCH**

DEAR SUPER-SECRET DIARY,

WELL, THAT CERTAINLY DIDN'T GO THE WAY I PLANNED. THE GUYS MADE FUN OF ME AND SAID MY ARMOR WAS PINK.

DELTA In Season 11, Donut's Basebook profile features a photo of him at Valhalla, or Ragnarok, as it is known in *Halo 4*.

PINK. CAN YOU BELIEVE THAT?

BELIEVE ME, BUDDY. I KNOW PINK WHEN I SEE IT.

WHATEVER. THIS ARMOR'S WAY MORE ROOMY AROUND THE CROTCH THAN THAT LAST SUIT.

ENTRY 9: **DAY 14 AT BLOOD GULCH**

DEAR SUPER-SECRET DIARY,

SOMETIMES YOU FORGET JUST HOW CLOSE WE ARE TO LEAVING THIS WORLD FOREVER. THE ONLY WAY I CAN TALK ABOUT MY NEAR-DEATH EXPERIENCE IS IN HAIKU.

> A BLUE SPIDER HISSED
> IT EXPLODED ON MY HEAD
> SOMEBODY BLEW ME
> UP

IT'S NOT A PERFECT HAIKU.

ENTRY 11: **DAY 18 AT BLOOD GULCH**

DEAR SUPER-SECRET DIARY,

YEARS OF TOSSING FINALLY PAID OFF!

WHAT I MEAN IS THAT I TOTALLY STUCK A GRENADE THROW FROM FAR AWAY. LIKE REALLY FAR.

I GUESS YOU HAD TO BE THERE. WHAT I'M SAYING IS THAT

IF THERE WAS A CHAMPIONSHIP EVENT FOR TOSSING, THEN THIS GUY JUST DEFENDED HIS TITLE AS WORLD'S BIGGEST TOSSER!

ENTRY 72: **DAY 111 AT BLOOD GULCH**

DEAR SUPER-SECRET DIARY,

A NEW DOCTOR SHOWED UP IN THE CANYON TODAY, WHICH IS PROBABLY FOR THE BEST SINCE NONE OF US KNOWS HOW TO TREAT BULLET WOUNDS. OR GRENADE WOUNDS. OR TANK WOUNDS. OR ANY KIND OF WOUNDS, REALLY. ALTHOUGH I KNOW HOW TO TREAT LANCED BOILS, BUT THAT HASN'T COME IN HANDY. YET.

THE FIRST THING THE DOCTOR DID WHEN WE GOT HIM BACK OVER TO OUR BASE WAS PIN SARGE AGAINST THE WALL WITH THE WARTHOG.

I ALWAYS THOUGHT IF ANYONE WAS GOING TO RAM SARGE UP TO THE WALL, IT WOULD BE ME, SEEING AS HOW I'VE BEEN ANGLING FOR A PROMOTION LATELY.

ENTRY 72: **DAY 115 AT BLOOD GULCH**

DEAR SUPER-SECRET DIARY,

TODAY I ALMOST GOT KILLED BY A TANK. IT WAS DIFFERENT FROM MY LAST NEAR-DEATH EXPERIENCE. THIS ONE FEATURED A ROMANTIC BALLAD, AND ME AND PRIVATE GRIF GAZING SILENTLY INTO EACH OTHER'S VISORS AS WE WAITED FOR THE END.

I THINK . . . I THINK HE FELT SOMETHING. A CON- NECTION.

MAN, I REALLY HOPE THIS IS THE LAST TIME I ALMOST DIE. I CAN'T TAKE ANY MORE SCARES.

ME

TANK

ENTRY 75:
DAY 118 AT BLOOD GULCH

DEAR SUPER-SECRET DIARY,

I AM OFFICIALLY A POW. AFTER OVERHEARING SOME REALLY DISTURBING THINGS THE PURPLE GUY SAID IN THE CAVE, I GOT A TEENSY BIT TURNED AROUND AND ENDED UP AT BLUE BASE. WHOOPS.

SO NOW THEY'VE GOT ME IN A CELL. NO FOOD. NO WATER. NO BODY LOTION TO KEEP MY SKIN MOISTURIZED. I DON'T KNOW HOW MUCH LONGER I CAN TAKE IT. THEY KEEP POUNDING ME FOR INFORMATION ABOUT THE REDS. WELL THEY CAN POUND ON DONUT ALL THEY WANT. SEND AS MANY GUYS AS YOU CAN TO POUND ME, BLUES. I'LL TAKE A POUNDING FROM EACH AND EVERY ONE OF YOU. THESE LIPS ARE SEALED.

ENTRY 76: DAY 120 AT BLOOD GULCH

DEAR SUPER-SECRET DIARY,

TODAY WAS THE MOST BORING DAY YET. EVERYONE ELSE WENT THROUGH THE TELE-PORTERS AFTER O'MALLEY, AND I GOT STUCK WITH THE ONLY TWO LADIES IN THE CANYON.

TEX COULDN'T EVEN GIVE ME TIPS ABOUT MY SPLIT ENDS.

ENTRY 80: DAY 132 AT BLOOD GULCH

DEAR SUPER-SECRET DIARY,

WOW. WOW WOW WOW WOW.

TODAY, I GOT BLOWN . . .

INTO THE FUTURE! A BOMB WENT OFF INSIDE OF CHURCH AND IT SENT ALL OF US INTO A FUTURE APOCALYPSE. WE HAVE NO IDEA WHERE CHURCH IS NOW, BUT ALL OF US ARE LOOKING PRETTY SPIFFY AND SHINY, EVEN IF THE SETTING IS KIND OF DRAB.

SINCE HE'S SURE TO BE CONFUSED WHEN HE WAKES UP, WE PUT TOGETHER A SKIT TO HELP EXPLAIN OUR SITUATION TO PRIVATE TUCKER. I'M THE DIRECTOR! OUR MOVIE WILL BE ALL ABOUT THE APOCALYPSE THAT HAS BEFALLEN OUR WORLD, AND THE BAND OF HANDSOME MALE SURVIVORS BRAVING THE ELEMENTS TOGETHER.

I'LL BET THE GUYS WOULD DO ANYTHING TO BE IN MY MOVIE. I'D BETTER TAKE ADVANTAGE OF THEM WHILE THEY'RE WILLING. TIME TO BREAK IN THE OL' CASTING COUCH!

ENTRY 83: **DAY 139 AT BLOOD GULCH**

DEAR SUPER-SECRET DIARY,

TODAY WE FOUND O'MALLEY'S HIDDEN BASE IN A BEAUTIFUL BEACHSIDE LOCATION. AND ME WITHOUT MY SWIMSUIT BOTTOMS! I JUST NEED TO FIND SOMEONE TO HELP ME APPLY THIS LOTION ON MY LOWER BACK, AND I'LL BE SET FOR SOME GREAT TIMES IN THE SUN. I'LL BET THAT WOULD BE RELAXING.

YOU KNOW, SPEAKING OF RELAXING . . .

WITH SOME TLC, WE COULD TOTALLY TURN THIS PLACE INTO A SPA/RESORT, COMPLETE WITH MANICURES AND FACIALS!

ENTRY 86: **DAY 147 AT BLOOD GULCH**

DEAR SUPER-SECRET DIARY,

TODAY WAS AH-MA-ZING. NOT ONLY DID I FINALLY GET TO KILL MORE PEOPLE, I GOT TO

DO IT ON A SWEET-ASS MOTORCYCLE! STRADDLING THAT HUMMING PIECE OF METAL REALLY DID SOMETHING FOR ME. NOTHING LIKE THE WIND ON MY HELMET AND MY LEGS WRAPPED AROUND SOMETHING PURPLE AND VIBRATING.

I FELT LIKE THE QUEEN OF THE UNIVERSE.

ENTRY 90: **DAY 155 AT BLOOD GULCH**

DEAR SUPER-SECRET DIARY,

SIMMONS'S POSITION AS SARGE'S PERSONAL BUTT-KISSER IS NOW VACANT. PRIVATE DONUT FINALLY HAS A CHANCE TO GET ON TOP!

WE'RE HOLDING A COMPETITION TO SEE WHO GETS TO BE SARGE'S NUMBER TWO. SO FAR MY ONLY REAL CHALLENGERS ARE A SKULL, A WRENCH, AND PRIVATE GRIF. AND WHILE GRIF AND I HAVE SHARED SO MANY CLOSE MOMENTS—I SAT ON THE GUY'S LAP, FOR CRYING OUT LOUD—I THINK IT'S TIME FOR ME TO SEIZE THIS THROTTLE WITH BOTH HANDS AND PULL WITH EVERYTHING I'VE GOT.

NEXT UP IS THE TALENT PORTION OF THE CONTEST. THERE'S NO WAY IN LIGHT-ISH RED HELL THAT A SKULL AND WRENCH ARE BETTER SWORD SWALLOWERS THAN ME!

ENTRY 93: **DAY 161 AT BLOOD GULCH**

DEAR SUPER-SECRET DIARY,

THIS MAY BE MY LAST ENTRY.

A SHIP FELL OUT OF THE SKY AND CRUSHED ME. I'M ALL FOR HAVING SOMETHING HEAVY ON TOP OF ME AND DRIVING ME

DELTA Donut washes his underwear on Tuesdays.

INTO THE GROUND, BUT THIS WAS JUST DANGEROUS! I'M LUCKY I'M NOT DEAD, BUT IT DID KNOCK ME INTO THIS DEEP, MYSTERIOUS CAVERN.

I'VE DONE MY SHARE OF SPELUNKING AND PLUNDERING DEEP, DARK HOLES, BUT THIS IS ON A TOTALLY DIFFERENT LEVEL. I'M GOING TO LEAVE MY DIARY IN THE HOPES THAT SOMEONE WILL FIND IT IF I DON'T MAKE IT OUT OF HERE ALIVE.

UNTIL THEN, THIS IS DONUT, SIGNING OFF. AT MY FUNERAL, I WANT YOU ALL TO REMEMBER MY CAREFREE SPIRIT, MY CAN-DO ATTITUDE, AND MY LOVE OF DAYTIME TELEVISION.

GOOD-BYE, BEAUTIFUL WORLD.

Dear Chairman,

Our records in this matter are impeccable and I will refer you to them. It is true that we were granted the use of only one AI program with special permission to conduct our experiments. That is all we were allowed to do, and that is all we have done. Of course, I am sure that you will agree, the core mission of any scientific endeavor is to find creative solutions to unexpected problems.

Sincerely,

Dr. Leonard Church

Director of Project Freelancer

THE WISDOM OF CABOOSE

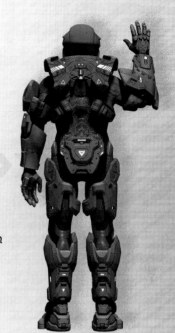

Underneath his bunk, Private Michael J. Caboose stashed a coloring book with dozens of notes scribbled across its pages in crayon. Taped to the front, a single piece of toilet paper, which read, "Everything I've Learned in Blood Valley."

ON FEELINGS

When your friend is sad, remind him of all the things in his life that used to be happy but aren't anymore.

If something makes you mad you should bury it deep down, where it can live forever inside of your hate hole.

You can't solve all problems with guns, but tank cannons are another story.

Robots are a good stand-in when you are depressed about your best friend leaving you forever and never coming back or calling on your half birthday.

Jealousy makes for an ugly bedfellow, mostly because it is green.

We have nothing to fear but fear itself, and also monkeys in overly big hats, because what are they even hiding under there?

ON RELATIONSHIPS

Be honest with the ones you love, unless you've been taking pictures of them in their sleep.

Not meaning to do something is the same as saying you're sorry.

Girls like being talked to and don't mind a little dirt under their treads.

Calling "bed buddies" before lights out doesn't mean you get to share beds.

According to Church, friendship time is when you stand as far away from your friend as possible. During friendship time it is not acceptable to talk to your friend.

Build trust with your teammates, because one day you might need to lie to them to get something you want. Like cookies.

DELTA Caboose's pinky toe was shot off in Season 2 by Church.

ON ARMY ETIQUETTE

Crayons don't work as bullets. Use markers.

The 5th and 6th pedals in Sheila are for time and space.

Putting your helmet on backward does not mean you can see backward. Or forward.

Even though the outside looks the same as Blue base, you can't find your underwear at Red base.

"If you have to go to the bathroom, just go in your suit" only works for astronauts and magicians.

The mess hall is not the place for messes. Do not leave your messes there, even though the room seems to be asking for one.

The illustrated field guide from Command is full of lies.

ON LIFE

A puppy is like a kitty, but with less Internet.

Babies come from swamps.

Shower time and food time are not supposed to happen at the same time, even though the shower looks like a really big sink.

Orange things: bananas, lemonade, the moon, yellow lights, Grif.

New catchphrase: My name is Michael J. Caboose, and I hate aardvarks ~~flamingoes social conformity tiny animals lottery tickets~~

If someone blows out your birthday candles, are they stealing your wish . . . OR YOUR BIRTHDAY?

Be the change you want to see in the world. I am a nickel, three dimes, and a penny.

ON THE REDS AND BLUES

Eating birthday cake when it's not your birthday won't kill you, no matter what Private Tucker says.

When Sarge and Donut talk about plundering, they are talking about totally different things.

There is no such thing as best friend juice, even if you pay Grif a lot of money for it.

DELTA Caboose is unnaturally strong. He was able to carry Andy in Season 3—something not even Agent Texas could do.

Things Tucker is going to do with the two ladies: ~~badminton the hokey pokey baking cakes go on walks~~

It is rude to stare at Red sergeants to figure out which leg is wooden.

Simmons is good at math because his mother is part calculator. And not the nice kind of calculator.

Everyone always says to give Tex a wide berth, but I'm not sure what a robot ghost lady would want with a baby.

 DELTA In Episode 21 of Season 10, "True Colors," Caboose is missing from the final shot where the Reds and Blues are surrounded by an army of Tex robots.

Dear Director,

Do your "creative solutions" include the circumvention of the safety protocols that every member of the military must follow? If they do not, then I fail to see how an enemy has managed to secure not one, but *several* of your experimental AIs. The protocol is not a guideline, dear Director, it is doctrine. And no one is above its rule.

Yours truly,

Malcolm Hargrove

Chairman of the Oversight Subcommittee

HERO IN MAROON

>>>>>>>>>>>>>>>>>>>>>>>

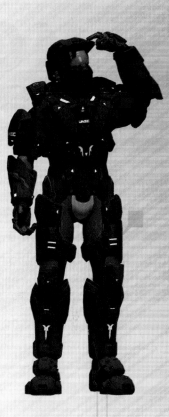

UNSC soldiers obtained several floppy discs beneath the bunk of Private Dick Simmons. The discs contained code for a text-based adventure game, presumably written and created by Private Simmons. Soldiers also found design documents tucked inside of his pillowcase. Where he developed the game or how he found 500-year-old working floppy discs is yet to be determined.

START—TITLE SCREEN

HERO IN MAROON—THE DICK SIMMONS STORY

[PRESS ENTER TO BEGIN]

A cold, bleak canyon in the middle of nowhere.
Savage idiots armed to the teeth. Dangerous for some, but not
Dick Simmons, Hero in Maroon.

Carrying an Assault Rifle, a wizard staff, his incredible intellect, and his natural
but often overlooked leadership abilities, the Hero in Maroon searches for his
friend and mentor, Sarge. Sarge considers the Hero in Maroon as his son and
favorite Red warrior. He doesn't necessarily say it all the time, or ever, but
the important thing is that the two of them have a mutual admiration for
each other.

Sarge, kidnapped by the evil Blue cannibals, must be rescued by the Hero in Maroon. Simmons will need every trick at his disposal, every last hidden magical artifact in Blood Gulch (real fantasy name to come later), every Red bone in his body to defeat the Blues and get the hug from Sarge he always wanted . . . and deserved.

[PRESS ENTER TO CONTINUE]

The Hero in Maroon's journey begins at the Cave of Sloth.

"I have a long journey ahead," he says, gazing into the ominous darkness. "I must not linger in the Cave of Sloth, or I might remain here forever."

[PRESS ENTER TO LIGHT TORCH]

"I have heard tell of a lazy cave troll that slumbers in these parts," he says expositionally. "Hopefully I will not run into him."

Simmons hears a noise, like the sound an extremely out-of-shape soldier makes after running just two hundred feet. Simmons turns to shine his torch on GRIF, LVL 5 CAVE TROLL.

Grif is fat, so fat that his troll body blocks the cave exit. Judging from his pungent smell, Grif the cave troll has not bathed himself in quite some time, nor has he taken the time to put his belongings back in his troll locker, no doubt irritating all the other, more responsible cave trolls.

Just saying.

[PRESS ENTER TO TALK]

"Disgusting cave troll Grif. I must pass through this cave to save Sarge."

"Oh, brave Simmons," Grif says, multiple chins wiggling. "You are such a good soldier, and I can never be like you."

"No," the Hero in Maroon agrees. "But be that as it may, you will let me pass, or I will strike you down with one of the attacks from my extraordinarily passive-aggressive skill set."

DELTA Simmons's desktop background is a picture of Grif falling into the cavern underneath Blood Gulch.

"I am just too pathetic," Grif the cave troll laments. "I have no choice but to allow you to do that while I neglect my duties, which are clearly marked on the Chore Chart hanging next to my bed."

[PRESS ENTER TO ATTACK]

SIMMONS USES THE SWORD OF PASSIVE-AGGRESSIVE JUDGEMENTALISM

"Heguhurghurk," Grif says. "Now I am dead." He dies, becoming a corpse only slightly more useless in death than in life.

SIMMONS SAVES A JAR OF GRIF'S FAT FOR LATER CONVENIENT USE

[PRESS ENTER TO CONTINUE]

The Hero in Maroon ventures to Red Base Keep, the cleanest base in all of Blood Gulch, where Sarge and Simmons forged their special bond. Simmons enters Red Base Keep with his head high and senses alert, using his special OCD ability to find anything out of place which might give him a clue to Sarge's whereabouts.

Simmons discovers a birthday cake.

[PRESS ENTER TO SMELL CAKE]

The cake smells vaguely of baby oil.

[PRESS ENTER TO TASTE CAKE]

No thanks.

[PRESS ENTER TO BACK AWAY SLOWLY]

Just as the Hero in Maroon turns to leave, the cake bursts open. Donut the Enchanter appears, spreading his temptation magic through scandalous dancing.

"Hero in Dark-ish Red," Donut says. "What brings you to this lonely base?"

"I am looking for Sarge," the Hero in Maroon says. "He has been taken captive."

"I always wanted to see him in bondage," Donut says. He continues to dance while he speaks. "Why have you inserted yourself into my home?"

"Why do you keep saying weird stuff like that?" Simmons asks. "Tell me what you know about Sarge, else I will have to run you through with my long sword!"

"I like where this is going," Donut says. "Maybe I'll keep you here . . . FOREVER!"

DONUT USES OFFICER HOT PANTS HANDCUFF ATTACK

"Oh no!" Simmons exclaims. A bed appears behind him. His hands are cuffed to it.

"Ha ha!" Donut laughs. "Now you must watch my rendition of the musical CATS!"

"Hurry, Simmons," the Hero in Maroon says to himself. "Use your intellectual aptitude."

[PRESS ENTER TO USE GRIF FAT TO ESCAPE]

Retching at the disgusting smell, Simmons slathers the Grif fat all over his wrists. Success! He slips free of the handcuffs. Then, grabbing his wizard staff, Simmons blasts Donut the Enchanter with magic.

"Best lube job I've ever seen," Donut says with his dying breath.

"Hmmm," Simmons says. "I'll bet I can use something here later on."

[PRESS ENTER TO GRAB DONUT'S SCENTED CANDLES]

A little creeped out but otherwise perfectly heroic, Simmons wanders across the vast canyon to find Sarge's mortal enemies, the cannibalistic Blues. He spots their base from afar. Using his powers of deductive reasoning, Simmons determines that the Blues are outside of their base making a campfire and talking about bullshit. The Hero in Maroon prepares for a fierce battle. Perhaps the fiercest he's faced yet.

[PRESS ENTER TO LAUNCH ATTACK]

Simmons unleashes the full power of his competent but ignored military abilities. The Blues scream in shock as he attacks with magic, smarts, and vaguely science fictiony weaponry.

"I am an idiot!" Caboose says, while doing something stupid.

"I have never actually been laid," says Tucker, the one Simmons is totally not jealous of because losing virginity is overrated and Simmons likes to keep his inventory stocked full of virginity at all times anyway.

"Something condescending," Church says. He dies, and nobody cares for a change.

[PRESS ENTER TO SEARCH BLUE BASE]

Inside, Simmons finds no trace of Sarge. Plus, it is very dark.

[PRESS ENTER TO LIGHT DONUT'S CANDLES]

A pleasant aroma of baby oil and cinnamon fills the air as Simmons lights the candles. Inside of a drawer, he finds something interesting.

[PRESS ENTER TO TAKE WEIRD MECHANICAL OBJECT
THAT WILL COME IN HANDY LATER]

A secret passage opens behind Simmons for no reason at all. It leads under Blue base, into the dark tunnels that lie beneath Blood Gulch.

[PRESS ENTER TO EXPLORE SECRET PASSAGE]

Simmons explores the tunnel for hours. He can't help but think of Donut the Enchanter.

Just when Simmons is about to give up, a figure appears in the distance.

[PRESS ENTER TO APPROACH MYSTERIOUS FIGURE]

Simmons approaches and realizes there is not one mysterious figure, but two. "It's Lopez! And he has Sarge!"

"Si," Lopez says, using the only Spanish word Simmons knows before a long, incomprehensible rant. Sarge sits in a cage behind him, bound and gagged.

"I can't understand a word you're saying," Simmons says loudly and slowly, so that Lopez might understand him. "But you're probably trying to become the leader of Red team because you're jealous of me and Sarge's relationship and fighting prowess!"

But Lopez is much too stupid to speak any English. Simmons has the distinct feeling he is being judged by the Red robot.

"That's it!" Simmons shouts. "Nobody takes my friend and lives!"

[PRESS ENTER TO LAUNCH FUTILE ATTACK]

DELTA In Season 1, Episode 3, Grif begins to tell a story about Simmons refusing to go to "Vegas Quadrant." This is a reference to an incident where Simmons's voice actor, Gus Sorola, refused to go to Las Vegas with the rest of *Red vs. Blue*'s creators.

Simmons tries to attack Lopez, but it does him no good. Lopez is cheating, since robots love to cheat and usurp their teammates to become the favorites of commanding officers. Not that Simmons is bitter about it or anything.

Simmons's bullets bounce off the robot's shield. Not even magic does the trick.

"Whatever am I going to do to defeat Lopez and rescue Sarge?" Simmons asks aloud.

And that's when he remembers the super-mysterious mechanical parts he found in Blue base.

[PRESS ENTER TO USE CONVENIENT DEUS EX MACHINA ROBOT DEVICE]

Lopez shouts a bunch of random words in Spanish that probably don't mean anything. Electricity crackles around him, and he falls down dead. Simmons rushes over to the cage and breaks it open. The Hero in Maroon throws Sarge over his back, action hero—style. Now Simmons is running, because the cave is exploding for no reason at all. Flames surround them as Simmons carries Sarge to safety in a feat of heroism the likes of which has never been seen before in any war ever.

When they arrive back in Blood Gulch, Simmons removes the gag from Sarge's helmet and unbinds his hands. Even through his visor, Simmons can tell that Sarge sees him with new respect.

"Good job," Sarge says, placing a single hand on Simmons's shoulder, "son."

[PRESS ENTER TO GIVE SARGE A TOTALLY MANLY HUG]

END CREDITS

Dear Chairman,

I, too, hold the Protocol in the highest regard. The doctrine kept us all safe during the Great War. If you are insinuating, sir, that we violated it in any way, or that we were derelict in our duty to the military, well then I suggest you be direct and tell me exactly how we did so.

Sincerely,

Dr. Leonard Church

Director of Project Freelancer

Dear Director,

Our laws are not designed to outline every possible infraction that may take place! However, the spirit of the law is clear. Blatant disregard for the safety and well-being of our citizens, in any form, will always be a punishable offense, regardless of how well or by whom that offense has been justified.

Yours truly,

Malcolm Hargrove

Chairman of the Oversight Subcommittee

THE CASE AGAINST SERGEANT GRIF

While in command of the Reds at Rat's Nest Outpost 25, Sgt. Dexter Grif committed enough traitorous acts to qualify for execution by firing squad, a punishment that has not been given to a commanding officer in over two centuries. Before Grif's sentence, the Reds had to build an ample case against him to establish a pattern of negligent behavior. Sgt. Grif made their job extremely easy.

RED ARMY CASE FILE NO. 41278
SGT. GRIF ACTIVITY LOG

GATHERED FROM SECURITY FOOTAGE, EYEWITNESS ACCOUNTS, INTERNAL DOCUMENTS

0600 HOURS

Red base rises to perform drills. Sgt. Grif takes an extended "Sergeant Siesta." He hits snooze on his alarm clock 16 times before waking long enough to declare a mandatory base-wide beauty sleep, citing that most of the Reds need it to be "less ugly."

0917 HOURS

Red team is forced to run laps because Sgt. Grif missed breakfast in the mess hall.

1026 HOURS

Sgt. Grif directs the Reds to go do "soldier stuff." Spends the next half hour looking at "videos" on the base's only computer, after ordering Private Dick Simmons to take down the firewall. For this heroic act, Grif names Simmons Super Private, Double First Class.

1100 HOURS

Sgt. Grif tries to find ammunition for his gun for 17 minutes. Says "fuck it," and takes a nap instead.

1203 HOURS

Sgt. Grif arrives early to the mess hall and locks the doors behind him. Nobody else eats.

1334 HOURS

A Warthog is checked out from the motor pool. Security cameras pick up Sgt. Grif driving around the track that connects the two bases. Grif must have gotten turned around, because he yells, "You suck, Blues!" outside of Red base for 45 minutes.

1421 HOURS

Sgt. Grif returns to the motor pool without the Warthog. When questioned about the missing vehicle, the sergeant says that some things are better left unexplained, "like the end of *Inception*."

1429 HOURS

Upon being informed that sergeants are held responsible for lost/damaged

vehicles, Sgt. Grif attempts to have Super Private, Double First Class Simmons delete the vehicle from Red army's registry. While browsing the system, Grif discovers the value of ammunition. He asks Simmons if the Blues pay similar prices on ammo, and mentions he "knows someone on the inside" at Blue base.

1457 HOURS

Whistling loudly, Sgt. Grif proclaims he is going for a "casual stroll." It is believed during this time that he first established contact with Blue soldier Michael J. Caboose, and then later, Private Jones.

1644 HOURS

An out-of-breath Sgt. Grif returns from his casual stroll, demanding an early dinner service at the mess hall.

1710 HOURS

Sgt. Grif is caught rooting through the troops' belongings by Private Cwierz. When questioned, Grif noticeably stammers before saying he suspects someone is hiding illegal contraband. "You know, fun stuff," he adds.

Cwierz informs Sgt. Grif that if he is concerned, he can easily order a mandatory search and seizure, a suggestion which Sgt. Grif likes so much he promotes Private Cwierz to Super-Duper Private, Quadruple First Class Plus. Stunned at the promotion, Cwierz recommends that Sgt. Grif issue a memo.

"What, like a telegram?" Sgt. Grif asks. They spend the next hour typing up the memo together.

1830 HOURS

Sgt. Grif brings the first of many memos issued during his tenure, proclaiming "dibs" on all personal items in Red base.

1911 HOURS

Sgt. Grif retires to his room for the evening, falling asleep on a pile of photographs of girlfriends, alcohol bottles, and granola bars seized from Red army.

RED ARMY MEMORANDUM 591

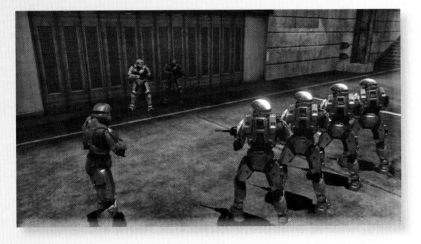

TO ALL MEMBERS OF RED TEAM,

STOP

This old-fashioned telegram is to inform you of some changes coming to Red base. STOP

First, it's important for you to know I am personally investigating our recent ammo shortage. I'll catch the resourceful, handsome opportunists taking advantage of our supplies. STOP

Since we're running low on ammunition, I'm placing the entire base in a state of emergency. The newly created DEFCON FUCKED means we're in some deep shit. STOP

As such, I'll be exercising emergency powers, granted to me by me, which entitle me to confiscate half of your daily rations for safekeeping. Can never be too careful, you know? STOP

Well, that's it, I guess. Try to do better and please win. STOP

Sergeant Grif

P.S. STOP STOP STOP

RED ARMY AUDIO TRANSCRIPT

In an unprecedented show of Red and Blue cooperation, Blue soldier Private Jones agreed to wear a wiretap during a rendezvous with Sgt. Grif. The Reds approached Jones in order to catch Grif in the act of selling ammunition. Private Jones agreed wholeheartedly to the operation, presumably to help place Private Caboose in the brig, where Caboose would be less of a danger to himself, others, and Blue vehicles.

Private Jones was later killed by Private Caboose during his discharge into the care of Recovery Agent Washington.

PVT. JONES: Walking, walking. Mic check one, mic check one, two.

PVT. CABOOSE: I like to talk to myself when I walk, too. Helps keep my feet straight. Left, right, left, left . . . wait. We have to go back and start over.

PVT. JONES: No. We're waiting here for your friends, Simmons and Grif.

PVT. CABOOSE: I like them. We've been through a lot together.

PVT. JONES: Yeah, yeah, you told me. You went to the future and saw an alien baby.

PVT. CABOOSE: The good old days. Donut died twice.

PVT. JONES: Here they come. Look sharp.

PVT. CABOOSE: I am a knife.

SGT. GRIF: Yo, wassup. J, you got the stuff?

PVT. SIMMONS: Why are you talking like that? And we're the ones with the stuff, not him.

SGT. GRIF: These shady deals remind me of my time in the joint, Simmons.

PVT. SIMMONS: You aren't a drug dealer. You're just a very bad sergeant.

SGT. GRIF: This is life on the streets, cuz. Got to fight to survive.

PVT. JONES: Can we just get on with this?

SGT. GRIF: Why you acting all nervous, J? You wearing a wire?

PVT. JONES: What, Jesus, no! Don't point that gun at me!

PVT. SIMMONS: Grif! Stop!

SGT. GRIF: I'll pop a cap, J, I swear! I swear I'll do it!

PVT. CABOOSE: Whoa. Be cool, man. Be cool.

PVT. JONES: Why are you telling me to be cool? He's the one pointing a gun!

PVT. CABOOSE: I have been looking for the right time to tell you this, Joenness. You are a very lame person. You need to be more cool.

PVT. JONES: Look, I just want the ammunition. I'll give you your money, and then we'll leave.

SGT. GRIF: You promise you're not wearing a wire?

PVT. JONES: Promise.

SGT. GRIF: Cross your heart?

PVT. SIMMONS: Is this how they do it on the streets?

SGT. GRIF: OK, fine. Your ammo is over here. Just let me go—

(Various soldiers rush the group from all sides)

REDS: Freeze! Freeze! On the ground, Sgt. Grif!

PVT. CABOOSE: Surprise!

 DELTA Every night before he goes to bed, Sarge sings a song about killing Grif, to the tune of "When You Wish Upon a Star."

SGT. GRIF: I'm not going back inside, Simmons! I'm not going back!

PVT. SIMMONS: Don't shoot! Don't shoot! I'm just following orders!

SGT. GRIF: It wasn't me! It was him! The maroon one!

REDS: Grif and Simmons, you're under arrest for treason. Thanks, Joenness.

PVT. CABOOSE: Surprise!

PVT. JONES: It's not a surprise party. We have to get out of here. Now!

PVT. CABOOSE: Is there cake?

PVT. JONES: Yeah. It's back at the base. In your cell.

PVT. CABOOSE: Mmm. Solitary confinement cake.

Dear Chairman,

Sir, while I appreciate your concern, allow me to correct you in one area. I value all our subjects' well-being, but I revere above all else our ability to continue as a species. Our ability to survive. And no committee, no bureaucrat, will ever convince me otherwise.

Sincerely,

Dr. Leonard Church

Director of Project Freelancer

LEONARD + ALLISON

After being locked down in the UNSC archives, the failing Epsilon capture unit retrieved by KIA agents Washington and Maine spit out a string of unique characters. Top analysts spent weeks decoding the data fragment, and oddly enough, it turned out to be a memory. One of particular importance to Epsilon.

The best trouble my mouth ever started was on my first day of Basic.

"Log on." Private Delaney punched the mess hall terminal loud enough to catch a few sidelong glances. I'd seen Delaney kick another guy's teeth in on the transport to Basic, so I knew to stay out of his way. Nobody could tell the computer terminal to keep its distance, though.

As far as meatheads go, Delaney didn't exactly fit the profile. Thin, wiry, twitchy. He was more like one of those little puppies that bites the shit out of you for no reason. But even the little dogs have sharp teeth.

"You stupid piece of shit! Log. On." The screen flashed when his knuckles connected.

I could almost feel the base's dumb AI scratching its digital head in confusion and saying, "Come on, guy, what the fuck?"

My stomach growled. The queue behind me grew another three people while Delaney swore at the machine in frustration.

"Buddy. Need some help?"

"Only if you can make this stupid goddamn thing turn on," Delaney snarled, trying to decide if he was more enraged at me or the terminal. Or maybe God, for shortchanging him in the IQ department.

"Here. Let me try." I sidestepped Delaney and put my face square in front of the terminal's sensor. "Hey. Can I log in?"

"Yes, Private," the terminal said, its voice almost relieved to be talking to a person with a functioning prefrontal cortex. "Please provide your ID and your password."

"There. Not so bad."

Delaney stared at me like I had performed black magic. "Why'd it work for you?"

"It's a computer. It just does whatever it's told. You don't have to punch it."

"What do you care?" A slow grin spread across Delaney's face, the kind of crooked look reserved for the universe's biggest assholes. "Are you sweet on it? One of those guys that gets off to computers?"

"No, I just didn't want you to starve to death because you're too stupid to operate a dumb AI. But I guess we'd just be short one idiot."

Delaney's punch just about knocked my head all the way back to Command. I flailed rather un-heroically as I tumbled past the line of people waiting for rehydrated mashed potatoes.

Shouting came from everywhere at once. Either the world was spinning or just my brain was. Delaney's boot doubled me over on the cement. The muscles in my stomach balled into a knot. Another punch. Lancing pain across my right eye. Blood dripped down on my hands as I tried to pick myself up. It wouldn't be the last blood I'd see there.

There seemed to be no escaping Delaney's stupid, unrelenting wrath. My legs were uncooperative. My mouth mushed together all the words I knew at once. All my brain could process was Delaney's fist.

"Hey! Asshole!"

Delaney turned away from pummeling me just in time to catch a haymaker that crushed his nose. I wonder if the AI was watching over the base's security feeds, just dying for Delaney to get his ass kicked.

A woman knelt down in front of me. "Hey. You all right?"

I remember the first time I saw the Orion nebula from a cruiser, the interstellar dust bursting with all manner of color against the black vastness of space. I stared out of that viewport thinking one day I might know the full limits of our universe, one day I could comprehend its depths and see every uncharted corner. But in just one second, I knew the opposite was true of *her*, this woman who had just punched Delaney—I thought I could spend a whole lifetime with her and not even know a fraction of her.

"Are you just going to sit there and bleed, or are you going to get up?" She peered at my face with a cringe. "Jesus. He really turned you into hamburger meat."

It took a couple of seconds to realize she was talking to me. "I'm Church. Private Church. Leonard. Leonard Church." The only thing I cared about in that moment was that she knew my name.

She smiled. Her smile could light up solar systems. "Kind of a funny name, Church."

"It's Jewish."

As if my senses weren't already scrambled, the sound of her laughter sent them into overload. I wanted to hear it on repeat. "I'll bet it is. I'm—"

Dear Director,

Please do not attempt to recast this investigation as some type of personal vendetta. Our questions to this point have been fairly standard. Your reactions have not. As such, we have secured all your records and logs by the authority granted us by the UNSC. Now we shall see exactly what it is that you have to hide.

Yours truly,

Malcolm Hargrove

Chairman of the Oversight Subcommittee

"Hey!" Delaney shoved past the crowd that had gathered to watch him bleed, his nose bent at a crooked angle. "We're not done yet."

The girl gave me a quick wink before appraising Delaney with disinterest. "I'm sorry, were you saying something?"

Chivalry didn't mean much to Delaney. The mystery girl barely had time to face him before he let loose with a wild punch. She easily sidestepped and hit him in the ribs with a one-two combo before finishing up with an elbow to his throat. Delaney's face went a shade of red usually reserved for fine wine, but that didn't stop him from leaping at her again.

This time there was no method to his attack. He was all rage, lunging with everything he had. Without wasting a moment, she planted a kick right between his legs, so powerful I'll bet his great-grandkids will feel it, should the universe be unlucky enough for Delaney to procreate. The private sank to his knees with a

horrible squeal. The girl must not have liked the sound very much either, because she shut him up with a final punch that flattened him out on the cement.

A chorus of cheers went up from the people who had all been held up by Delaney's idiocy in the lunch line. My mystery girl took a bow for her sudden audience, turned, and walked away from the mess hall.

Even though I could barely walk, I chased after her. "Hey! Wait! You didn't tell me your name!"

She turned, giving me another one of those smiles. "It's Allison. You're welcome, by the way." And then she was gone, lost in a sea of new recruits.

"Good-bye, Allison."

I spent the rest of Basic chasing after her. In some ways, I never stopped.

Dear Chairman,

I imagine this investigation of our program is providing you with the kind of attention that politicians crave so much. How very predictable. What has surprised me most about mankind during the Great War is not our ability to adapt to the new arenas of conflict, but instead our willingness in victory to so quickly return to the old.

Sincerely,

Dr. Leonard Church

Director of Project Freelancer

UNDER THE SAND

Audio transcript of debriefing session with Private Lavernius Tucker after the shutdown of Project Freelancer. This was just prior to transport to the Hand of Merope, *which stranded the Reds and Blues on Chorus. Retrieved from Archives in light of recent alien temple activity on Chorus. Interview conducted by UNSC officer Tabatha Morales. Later re-conducted by UNSC officer Marvin Dyes.*

MORALES: Private Tucker. Sorry I'm late—

TUCKER: Whoa! It isn't mine! I wore protection!

MORALES: Uh . . . excuse me?

TUCKER: Sorry. Force of habit. Kind of freak out whenever a lady uses the word "late." I've already been an accidental dad once, you know?

MORALES: Right. Of course. So. About your debriefing.

TUCKER: Bow chicka bow wow.

(Morales sets her files on the table roughly.)

TUCKER: Go ahead, baby. Debrief me.

MORALES: This is an official appointment, Tucker. If you don't cooperate with me you'll have to cooperate with someone else. Now. About your . . . check-in. We lost contact with you shortly after your arrival at the alien temple.

DELTA Because Tucker was the soldier who activated the ancient alien sword, it only responds to his touch (much to the chagrin of Agent Texas).

TUCKER: That was like, so long ago. All I remember is you guys not sending any fucking backup.

MORALES: Your distress signal was intercepted at Command . . . and then deleted.

TUCKER: Who was the genius who did that?

MORALES: Your friends on the Red team.

TUCKER: OK. That's not that surprising, actually.

MORALES: You mentioned your son, Junior. He was your partner?

TUCKER: Yeah. We went on missions to spread alien-human love or some shit. Like ambassadors.

MORALES: And where was he while you went to the temple?

TUCKER: They sent him to a colony on the outskirts to talk down some alien zealot dudes who weren't too happy with the treaty at the end of the war. Haven't heard from him since.

MORALES: You're not worried? He could be hurt.

TUCKER: Yeah, or he could be getting some alien girls pregnant. Probing some female life forms.

MORALES: According to my file, he's two.

TUCKER: We Tuckers get started early.

(Morales sighs.)

MORALES: In my notes I have that Junior was kidnapped by the AI Omega?

TUCKER: Fine, we'll do the stupid interview. Yeah, Omega and Tex took him on a ship. But my kid's a badass and he escaped in the confusion during the crash. I found him a year after the Pelican disappeared from Blood Gulch. The ship crashed two months later in Valhalla. There was some weird time shit going on.

MORALES: So you went to the temple alone.

TUCKER: Went there alone. Stayed inside it alone. Lots of alone time.

MORALES: And you defended it for months before the Reds and Blues came to your rescue?

TUCKER: Rescue? More like they almost got killed by CT and then I saved their asses. Because I'm awesome. Wait, months? Is that how long I was in there?

MORALES: Three months and seventeen days.

TUCKER: Ugh. Totally lost track of time in there. No wonder my balls are bluer than Caboose. Speaking of which, what are you doing after this?

MORALES: Let's call a quick recess.

TUCKER: Is that code for "let's turn off this equipment and use it to make dirty movies?"

(Morales leaves.)

TUCKER: Hello? You didn't answer my question!

(Two hours later, Morales returns.)

MORALES: All right, Private Tucker, let's try this again . . . what . . . where did you get candles?

TUCKER: Don't worry about that. Let's talk about my heroic exploits.

(Morales sighs audibly.)

MORALES: Let's start from the beginning. You went to the dig site and encountered CT.

TUCKER: That dude was the biggest dick. I show up and he's there pretending like he runs the damn dig site. I start asking questions about the alien representation, he notices my sword, and then he just starts shooting. And then there was this epic battle and I killed a whole bunch of them singlehandedly.

MORALES: Wait . . . a sword?

TUCKER: Swish swish stab, baby.

(Sounds of crackling energy.)

TUCKER: It's also a key. And the answer to some holy prophesy. That's how I roll.

MORALES: And you're just carrying that around? You have to report that!

TUCKER: Um, I called *dibs*. That shit's sacred. And it's not like it's going to work for anybody else anyway.

DELTA After Tucker and Junior reconnected, the two went on a journey to the alien home planet, where Tucker learned how to use his sword to greater effect.

It only responds to badasses. But I mean, you can try to hold my sword if you really want. All of those guys at the temple did. Wait. That didn't come out right.

MORALES: How many did you say you killed?

TUCKER: At least like . . . forty-seven. Yeah, probably that many. Or more.

MORALES: Forty-seven. By yourself.

TUCKER: Hey, I'm a fighter, not a lover. Well, I'm a lover, too, but you know what I mean. The point is: I killed a bunch of bastards and kept something important out of enemy hands and surely that deserves to get someone laid around here. Or at least a thanks.

MORALES: Thanks. So what ended up happening to the artifact?

TUCKER: Oh, Church? Um, I have no idea what happened to that floating ball, actually.

MORALES: You lost the alien artifact you spent months trying to protect?

TUCKER: You know, now that I think about it, that ball is still at that

Freelancer storage facility. Church got a new body there, and then Tex beat the shit out of him with his old body.

MORALES: That doesn't seem physically possible.

TUCKER: That's what we said!

MORALES: OK, let's go back to the temple. Nothing else of note?

TUCKER: Not that I can think of. Why?

MORALES: Just trying to be thorough, Private.

TUCKER: I got something else you can be thorough with. My—

MORALES: That's it. I've had it with you guys. We'll conclude your session at a later time.

(Morales stands up, still talking.)

MORALES: I swear, they don't pay me enough to deal with you idiots. Sarge thought I was a Blue in disguise. Caboose acted like I was *his* prisoner, and I'm pretty sure Grif was eating in his helmet the whole time! I'm done! I can't wait for all of you to ship out of this damn base.

(Morales slams the door behind her.)

TUCKER: She'll be back.

(Typing on the keyboard.)

TUCKER: Oh, hey. This place has Internet. Bow chicka click click.

VOICES OF CHORUS

We've pulled key logs from what's left of the New Republic databases. These records highlight activity that sheds light on the weeks leading up to the Reds' and Blues' arrival. In nearly all instances, the significance of these events goes entirely unnoticed by the rebels.

A LA MODE–POSTED BY LT. BITTERS

Today, Kimball rounded up the New Republic troops (or what's left of us) to deliver one of her speeches. She does this from time to time, whenever things are going particularly bad or particularly good. Right now, things are just the regular kind of bad, so I found the timing kind of weird. Usually her speeches are filled with a weary sort of optimism, like she's feeling the weight of every Chorusan she's sent to his/her death. She's an equal opportunity gal.

But today, the speech was different.

Call me crazy, but I swear I could hear a smile behind her helmet. The speech was vague, like always, but she left us with a word she hadn't used in a long time: hope. Haven't had much of that lately.

I knew something was up when they busted out the ice cream after. Real rocky-fucking-road ice cream. I dunno how many dead Chorusans' pantries they had to raid to get the stuff, and it was freezer-burned to hell, but man . . . it hit the spot. I'm not sure that Palomo kid had ever had ice cream before. He took one bite, then immediately shoveled the rest into his mouth. The resulting brain freeze had the whole mess hall in stitches while he rolled around shouting. I swear, even Kimball was laughing by the time he recovered and asked for more.

Something really fucking weird is going on around here.

TOO SPOOKY–POSTED BY LT. PALOMO

I went for a stroll around the base last night. I guess it wasn't really a stroll, more of a leisurely walk. Well, maybe not leisurely. More like lackadaisical. Then again, a lackadaisical walk is really just a stroll, isn't it?

So I went on a lackadaisical stroll/walk thing around the base last night, and in the middle of it I got this funny feeling. Like I was being watched, but worse. I mean, it felt like there was someone *right there*, right in front of me, but I just couldn't see them!

This isn't the first time, either. Sometimes I get the feeling in the halls or down near the docks. I hear other guys talking about it too. They say maybe it's the ghosts of all the people who've died in the war, but if that were the case then I think we'd be getting these creepy feelings a lot more often! You know, on account of all the dead people on this planet. Which is also creepy when you think about it. And sad.

Whatever it is, I don't think I'll be strolling quite as leisurely on my evening patrols. Shit's too spooky to be lackadaisical anymore, yo.

BAD DAY–POSTED BY LT. SMITH

A good soldier should be ready to adapt. Situations may change in an instant on the battlefield, and today, what was supposed to be an ordinary supply run became an all-out firefight in a matter of seconds. You always think you'll be ready for it, but you never know if you will be.

The Feds knew.

They were waiting for us. More specifically, *he* was waiting for us. Locus ... along with three squads and two G-Men with their chain guns dug into the hillside. We lost a lot of good men, and we would have lost more if it weren't for Felix. He managed to neutralize two cloaked

Dear Director,

It is now clear that your agency and its primary program "Project Freelancer" have abused the trust and freedoms that the Oversight Subcommittee has provided you. Your abuse of the Alpha AI will now become the subject of a criminal investigation. I am sorry, Director, but you have seen the end of my patience.

Yours truly,

Malcolm Hargrove

Chairman of the Oversight Subcommittee

enemies that were preparing to flank us. I don't know how he does it. It's as if he has some sort of sixth sense. Always in the right place at exactly the right time.

He and Locus make the rest of us look like amateurs. The way they fought each other was like nothing I'd ever seen. Each shot was dodged just in time, each punch blocked at the last second. They were perfectly matched. I'm not one to partake in gossip, but the popular belief around base is that they used to fight together. I guess that would explain a lot. I can't even describe what it was like to watch them.

Felix, though . . .

As much as I admire what the mercenary does for us, I just can't bring myself to respect him. He kept cracking jokes on the way back to base. I know that sardonic detachment is kind of his shtick, but it's always made me uneasy. Like he's laughing at a punch line the rest of us just haven't gotten yet.

Bad day, I guess.

RANDOM WHATEVER–POSTED BY LT. BITTERS

Felix got us a new Warthog today. It was pretty banged up, but they've got Lt. Jensen working on it, so it should be good to go in no time. Girl's crazy-smart. It's actually kind of depressing when you think about it.

A lot of the soldiers here are too young to remember what it was like before the war, but I'm just old enough to know, and I think knowing makes it worse. This nerdy goofball sits around engines and axles all day, fixing them up just so they can break again. It makes you wonder what she'd be doing if it weren't for all of this bullshit, you know?

Daydreaming aside, I came to terms a long time ago with the fact that we're all probably going to die a horrible death, but there's little things every now and then that still make this fight worth fighting.

For example, despite all of her knowledge on cars, Jensen can't drive worth a damn. You'd think someone who works with vehicles all day would know what she's doing behind the wheel, but she's *such* a klutz. Then there's that Smith guy. Dude is JACKED, super strong, super smart, *perfect* soldier, but he just doesn't see it. Instead, he listens to whatever his commanding officers tell him and doesn't question a word of it. I *know* this guy could be a badass if he didn't play everything by the books, but he's straight as an arrow. Makes you wonder how someone like that ended up in a *rebellion*, of all places.

It's just lots of little things that are kind of funny, I guess. Terrible, but funny. I dunno.

OMG HEROES—POSTED BY LT. JENSEN

A ship crashed! I suppose normally that would be horrendous, but this is an absolute exception! Some time ago Felix told Kimball that he intercepted a radio transmission from a canyon not too far from here. Apparently survivors of a UNSC shipwreck are broadcasting on all channels trying to hail a rescue. I'd tell them that it's pointless, seeing as we haven't had contact with the inner colonies in forever, but—OH MY GOSH I TOTALLY FORGOT TO TALK ABOUT THE BEST PART!

These people that crashed, they're *soldiers*, and not just any soldiers, but super-incredible-hero-soldiers! Apparently these guys brought some corrupt organization to justice with just a small team, a robot, an artificial intelligence program, and a couple of "Freelancers." At first I didn't know what the heck any of that meant, but Felix pulled up all sorts of data on the guys and they sound super legit!

There's only one problem. Remember how I said they were broadcasting on all channels? Yeah, that definitely means the Feds picked up on that transmission too. Ugh, I'm SO ANXIOUS RIGHT NOW. Kimball's sending Felix out with a couple of volunteers to do recon. For all we know, the enemy has already located these "Red and Blue" soldiers and is just waiting for us to try and swoop in. Oh, but maybe *we* have the upper hand and now is our only chance to get there first! I justttttTTTT 134 JNLNLKJLAKNJLK

LLLLLL

LLLLLL

LLLLLL4

Drat. I dropped my tablet. Note to self: stop pacing around the bunk while typing.

I should get some rest but I'm just too excited to sleep! Gosh, I hope Felix brings them back.
If they're as heroic as we all think, I'm sure they'll happily aid us in our struggle for freedom!
That's what heroes do, right? They help out the good guys without thinking of themselves.

I'm already getting ideas for fan fiction...

Dear Chairman,

I don't give a damn about your committee and its opinions of
my work. Have you forgotten, sir, we were at war? A fight with
an alien race for the very survival of our species? I feel I must
remind you that it is an undeniable, and may I say a fundamental,
quality of Man that when faced with extinction, every alternative
is preferable.

Sincerely,

Dr. Leonard Church

Director of Project Freelancer

To the Director of Project Freelancer,

I write to inform you that by the authority of this Subcommittee, officers have been dispatched to place you under arrest, and we expect your full cooperation. Congratulations are in order, I suppose. When they write the new morality protocols for dealing with AI, I'm certain they will name entire sections of the doctrine after you. It seems that you will earn your place in history after all, **dear Director**.

Yours truly,

Malcolm Hargrove

Chairman of the Oversight Subcommittee

PAGE TO SCREEN

>>>>>>>>>>>>>>>>>>>>>>>>>>>>>

Every moment of *Red vs. Blue* starts on the page. Between the words typed in Austin, Texas, and the hilarious images broadcast to millions of fans each week, a world of production takes place.

From voice acting and puppeteering to animation, editing, and special effects, incalculable hours are invested into every single second of *Red vs. Blue*. This section highlights the key episodes and historic transitions of the series, and the journey that happens from page to screen.

WHY WE ARE HERE

BY BURNIE BURNS

Series writer and creator Burnie Burns revisits the iconic first episode of Red vs. Blue, *diving into its creation, its subsequent effects on the lives of him and his friends, and how it informed the entire series moving forward.*

The precise moment of any artistic inspiration can be hard to pinpoint. It usually builds over time until there is an overwhelming need for a creative person to make something, but rarely is there that metaphorical lightning bolt that strikes a person. *Red vs. Blue* is no exception. I can't remember sitting around one day and thinking that I should drop everything and use my video game console to create a 200+ episode web series.

Still, there has to be a moment when that spark is first realized, when an artist knows *something more is here.* That this gnawing in my belly is trying to tell me something and it's not going anywhere unless I do something about it. If I had to pick that moment for *Red vs. Blue*, it went something like this:

"Huh. That kind of looks like a movie."

That was my first thought when I took the video game *Halo* and put a black bar over the ammo counter at the top of the screen and another over the gun at the bottom. I wish I could say that I did this because of some grand idea, but in truth I was just plain bored. I had already made a dozen videos showing off my skills in *Halo* and I felt as though they were identical to every other game montage on the Internet. Using the best clips from my most recent match just didn't cut it anymore. Letterboxing the video and having one of the onscreen heroes talk seemed like a good way to punch that up. Seeing that cinema-style image on my screen changed my perspective.

Something more is here, that gnawing feeling in my stomach said.

Since any great artistic or scientific revelation requires verification, I showed it to my friends Gus Sorola and Geoff Ramsey. Did it look like a movie? Their support was overwhelmingly positive:

"Huh. That does kind of look like a movie."

I had my confirmation. This did indeed kind of look like a movie. If I could use this technique while controlling the onscreen characters in real time, I could write and act out scenes that starred my friends. If it worked, I could build on that and write more characters. Then I might even have a movie that kind of looks like a movie. Sounds like a pretty simple concept, right? Nope. Trying to explain *Red vs. Blue* proved extremely difficult without another example to point to. People either asked, "So you want to make a video game?" or dismissed the idea with, "That sounds like a cut scene in a game."

I wrote up a quick script, went over to my two friends' houses and jammed microphones in their faces. Luckily, this seemed like a very normal thing to them. I fed them their lines.

"Say this. OK, now you say this. Be angrier. You, be lazier."

I took my freshly recorded dialogue

home and spent the next seventy-two hours making the trailer for *Red vs. Blue: The Blood Gulch Chronicles*. The actual dialogue portion was just two lines at the end of the video—only eight seconds out of two minutes. That was my proof of concept. Once I had that, then I could better explain to people what I wanted to attempt.

"Oh, so you want to make a movie."

Yes. Sort of.

HURDLE HOPPING

My film career in college was short lived. I was a computer science student who thought the best way to learn about filmmaking would be to make an actual movie. Once again, it seemed like such a simple idea. The only film student I could find who understood such a crazy notion was my friend Matt Hullum. We started our business relationship after only a few short conversations. We were going to make a movie.

Fast-forward a few years, and we had produced a feature film shot entirely on 16mm film. I had only lost nine thousand dollars and one girlfriend in the process—not bad by entertainment industry standards.

The biggest thing I learned from making a feature film is that making it is only half the battle. The other half is taking your completed piece of work and showing it to an audience.

Or rather, *trying* to show it to an audience.

In today's world of instant access and social media sharing, this will be a foreign concept to many of you. But as a filmmaker in the late '90s, I would spend weeks trying to solicit selection committees at film festivals to allow me to show my movie to a small room of about two hundred viewers. That's the way things worked back then. People went to these special buildings with small rooms and sat in the dark together to watch a movie. There was no comment box. No Like or Subscribe. In fact, you weren't even allowed to talk to anyone in the room. You simply faced forward and kept to yourself. Sometimes you ate very expensive food that was provided. After the movie, you walked outside and had a four-minute period in which to talk about the movie, but only with anyone who actually came to the movie with you. If the movie was good, they would put it in more of those buildings, and give you more dark rooms in which to show it.

If that strikes you as dumb, I was dumber: I spent a year of my life trying to break into that world. Then one day, I posted a video online.

Instead of jumping through the hurdles of distribution, I could bypass everything. Even saying it that way sounds funny—I was bypassing traditional "distribution" by actually *distributing* my work myself. I could put a video online and then instantly anyone who wanted to see it . . . could see it. It was an unbelievably empowering experience and still the most powerful part of what we do on a daily basis. Except now we have the comment box and the Like button.

You should totally click that, by the way.

WEB HISTORY

The first episode of *Red vs. Blue* went online and we didn't have a way to figure out who was watching it. Back then, all we had was a hit counter that showed us how many people visited the page. We estimated that number to be about 3,000. From there, the video was passed around in e-mail and shared physically on CD, or the oldest distribution method on the Internet, someone saying, "Hey, come watch this thing."

We have all seen or heard about a video on the Internet going viral; when something hits a kind of critical social zeitgeist that sends its viewership into the stratosphere. Experiencing that firsthand was one of the most amazing moments of my career.

Within just a few hours the views went from a trickle to a flood. Since we're talking about the days before YouTube existed, this actually became a problem for us. A big problem. We had to figure out a way for all these people to actually see the damn videos. That meant renting servers and providing bandwidth for viewers all over the world. There was no convenient "click here to upload" button on a friendly YouTube interface. It was all rented servers and co-location facilities scattered across the country.

I discovered that trying to *get* distribution and actually providing distribution are two

totally different things, and they are both equally unglamorous. I had a newfound appreciation for the machine I had been battling for the past few years, with a renewed vigor to conquer it in a different way.

Once we straightened out the servers, it was smooth sailing. Or as smooth as five guys crammed in a spare bedroom making content for the Internet can be. Also, not porn. I still feel the need to tell people that my bedroom-based Internet content company did not make pornography. I probably would have lived in a much nicer house if that were the case.

NEW METHODS, NEW PROBLEMS

Filming in a video game wasn't perfect.

When I sat down to write the story for Season 1 of *RvB*, I immediately realized my biggest challenge. These are eight characters that all look exactly the same. *Literally* the same, except for variations in color. In some cases, like Simmons's maroon to Sarge's red, the differences weren't even that different.

I set out to design characters that would stand out on their own. I wanted to have ordinary people inside these suits—people you could possibly run into every day of your life. We all know a slacker, an idiot, a bossy jerk, a person who is remarkably inappropriate, and a guy too smart for his own good. I wanted to make these characters so clear that no one watching the show could possibly get confused about who was talking.

That was only the first hurdle. The second was that no matter what I wrote, it had to be acted out in *Halo*. Which sounds tough enough, given the limited nature of the environment, but consider this: a video game only has as many verbs as there are controls. In the original *Halo* you can move (left stick), turn (right stick), jump (A button), hit (B button), shoot (trigger),

throw (left trigger), crouch, and reload. That's it. Try writing a story where the characters can only move, turn, and attack. No sitting, no pointing. (I would have killed to have a "point" button.) Unfortunately, no one wants to play the pointing game on the Xbox. Shooting and jumping are far more popular.

Which meant almost every joke in *RvB* had to be spoken. The verb "say" was the only new verb we could bring to the table, and believe it or not, that is where our creativity blossomed. Sure, it would be great to have a character change a lightbulb while standing on a ladder, balanced on top of a folding chair, but we couldn't show those things because they did not exist in our kind-of-looks-like-a-movie world. Because of that limitation, we were forced to write a funny story for our audience from the very first episode. And you know what? It is one of the many things that made the show better. Oddly enough, placing limits on our storytelling abilities forced us to be more creative. We had to adapt.

Years after that first episode of *RvB* hit, we were lucky enough have a very talented animator named Monty Oum join our staff. In the early days of his hiring (way back in *Season 7: Recreation*), Monty and I spoke at length about the characters and what they might do when their actions could expand beyond what the Xbox controllers told them to do. We would talk for hours, almost to the point where I didn't know what direction to take a scene. And that's when Monty pinpointed an issue: now that the characters can do anything, we feel compelled to do everything. We were plagued with a paralysis of possibility.

Looking back on those first seasons, especially that first episode, I'm glad we had those boundaries. It was more like a playpen than a fence. In the early days we could never show Sarge hoisting Caboose up on his shoulders to peek into a window. Instead we had to frame a funny shot of Caboose's head poking in the window while Sarge grunts and complains off-

screen. That limitation made us approach the scene in a way we might never have thought to do before. It's a funny solution that looks like intentional design.

And I owe it all to *Halo*.

I owe a lot of things to *Halo*. Without my many hours spent obsessing over my own gameplay videos, my own matches, my own kills, I might never have noticed some of the quirks that led me to write jokes about the Warthog, the flag, and so on. I might never have realized the potential that existed within the game that I loved so much.

No, we weren't making porn in my bedroom. We were just making irreverent comedy content and pushing it straight to the audience. Every day from the very first video, I woke up and went to work on something I liked. Something I wanted the world to see. It was a dream come true.

And despite all odds, yeah, it still does kind of look like a movie.

HEADBOBS TO KARATE CHOPS

BY MATT HULLUM, WITH NOTES FROM MONTY OUM

Director Matt Hullum and animator Monty Oum discuss the evolution of Red vs. Blue's visual style, from its origin as unadulterated Halo machinima to the later seasons that married machinima and heavily choreographed CGI animation.

Matt and Monty were lucky enough to have this conversation before Monty Oum passed away in February 2015, during the production of both Red vs. Blue Season 13 and this book. Monty, along with his insight and wisdom about the creative expression of animation, will be missed a great deal.

I can't think of another series, in any medium, that has undergone as much change as our show. Over the last decade, we've changed the visual style of *Red vs. Blue* about once every two years.

Each change brings its own set of challenges. We were so burned by our decision to use *Halo 2* during the middle of Season 3 production that we decided we would never change game engines so quickly again. That first set of *Halo 2* episodes endured numerous growing pains (although the remastered edition DVDs eliminated all of them).

We gave ourselves a full year to play around in *Halo 3*'s maps and newly created theater mode before we jumped into production for *Season 6: Reconstruction*. It was like gradually moving toward the deep end of the pool from the kiddie section, rather than doing a kamikaze cannonball off the diving board like we had in Season 3's move from *Halo* to *Halo 2*. We learned a lot about what was possible in the game's new toolset, and what difficulties were waiting for us that we had to find a way around.

When *Reconstruction* hit, we swung for the fences. The first shot alone had more soldiers on screen than any episode we had shot prior. The story itself was a whirlwind, visiting almost every map that shipped with the game, and even some that hadn't. We added tons of new cast members. We moved beyond bad Photoshop jokes to include some very intricate special effects shots, many of which went unnoticed by fans (as the best special effects often are).

But we had a problem. What more could we do in *Halo*?

Burnie always joked that for a long time *Red vs. Blue* was based around just five verbs—walk, run, jump, crouch and shoot—which are the only actions you have at your command in *Halo*. (I guess we should throw "headbob" in there too.) Over the course of six and a half years we had used those verbs about as creatively as you possibly can, and we were ready for some new ones, like karate chop.

REANIMATED

Prior to working on *Red vs. Blue*, my background consisted of work on animated features. I had worked in L.A. with Kathleen Zuelch, the voice of Tex, on a couple of projects like *Clifford* and *Scooby Doo*. Basically I was good at animated dogs. There weren't any animated dogs on our show, but it couldn't be that different, right? Our first foray into animating the Red and Blue goofballs everyone loves resulted in *RvB: Animated*, a cartoon that we debuted at PAX in Seattle back in 2008. For the first

DELTA The animation work for *RvB Animated* was done by a Florida-based studio named Humoring the Fates. Ben McSweeney, who did much of the animation, also designed the Rooster Teeth logo.

time, we had new gestures and actions at our disposal, which opened up a bunch of new story possibilities.

But we had no actual animation talent in-house, and we quickly realized there were some problems with outsourcing so much of the production work to another studio. For one, it was expensive. It turns out that creating each individual animation asset from scratch requires a lot of work. And the turnaround times, although quick by traditional animation standards, were out of sync with the blazing fast speeds we had become accustomed to with machinima. But third, and most importantly, we felt like we had lost touch a bit with the production. There's something about being hands-on—literally holding the Xbox controller in your own hands—that was an essential element of our style.

We were still excited about the idea of expanding the scope of *Red vs. Blue* production, but we realized we needed to find another way to do it.

SETTING A NEW BAR

If we were going to add animation to *Red vs. Blue*, we wanted to set the bar all over again—and as high as we possibly could.

Enter Monty Oum.

In our many hours spent watching videos online (let's just call it research), we stumbled across Monty's video *Haloid*, in which a Spartan from *Halo* faces off against Samus from *Metroid* in a huge,

MONTY: "I got involved with Rooster Teeth at San Diego Comic-Con, where Burnie Burns and I happened to be on a panel together. The panel itself wasn't as important as the discussions we had afterward. I had been a fan of *Red vs. Blue* since Season 1 and watched it religiously, especially in its early seasons. I was a big fan of *Halo*, and what they were able to create with the engine was something I identified with greatly. I had some theories about what I could add to *Red vs. Blue* with my ability to animate. After sending a few tests, I ended up moving to Austin, Texas, and have been working here for nearly five years."

Matrix-esque brawl. The video had a great blend of action and comedy that we knew we wanted in *Red vs. Blue*. As it turns out, Burnie ended up on a Comic Con panel with Monty just a few months later. It wasn't long before Monty moved to Austin and was working at Rooster Teeth full-time.

GROWING PAINS

There were definitely technical hurdles with Season 8, but overall it was a surprisingly easy transition. I think it helped that most of the early animation was all about the jokes, like Doc getting stuck in the wall. We thought, "We've got a lot more power at our disposal now, we have to make sure we continue to use these new tools just like the old ones—completely irresponsibly."

Honestly, the biggest challenge was trying to balance the new look of the animated sequences with the machinima sequences. We were a bit surprised by how much work it took to make the animation look like the game. There were a lot of seemingly small details like the grass on Valhalla and the number of sparks in an explosion that are so particular to *Halo 3*, they make the whole scene feel wrong if you mess them up or leave them out.

We tried to be very careful about our approach with animation. We didn't want to mess up the legacy of the show by doing something that might be viewed as conventional, even though for us it was completely unconventional. The best feeling was watching it with an audience for the first time. When the Warthog crashes through the wall, that was us announcing our new direction. We wanted to tell the audience in a loud way that we're breaking down walls—the limits we had in our production—and hopefully smashing all your prior expectations.

MONTY: "Although we came from very different backgrounds, we laughed at the same things. I loved the humor of *Red vs. Blue*, and we discovered the addition of my work brought not only an action element to the show, but also physical comedy. Many of the first scenes I worked on were action gags that involved both spectacle and humor. As time went on, especially in Season 8, I added even more physical gags that were true to the characters because I was so familiar with the show. It's something I live by that when making something, rather than pitching it, I can make a better argument by simply doing it so well that it can't be refused. Very rarely did we want to throw out something I had worked on, for that reason."

TAKING IT TO 11

We wanted the first huge fight of Season 8 to be something monumental in the series. But what to do?

The answer: teleporters.

Since Season 1, Episode 10 is usually the Tex episode. Monty's fight choreography gave us the chance to do something really amazing. I was excited (and a little concerned) about being able to show what an actual badass Tex really is. It seems like in many long-running narratives you often come across those larger-than-life characters that are described as amazing beyond all comprehension. Yet when their moment comes to shine they often fall flat. I wanted to make sure that didn't happen with Tex.

The big breakthrough during production of that episode was that it was the first time composer Jeff Williams, Monty, and I had all collaborated intensely together. I tried to shape what Monty was doing with animation, what Burnie was doing with writing and machinima, and what Jeff was doing with the music, to bring them all together in a way that would make them cohesive, and hopefully bigger than the sum of their parts.

As Monty likes to describe the process, it was like making stir-fry, and whenever we got a new ingredient we would try to find a way to mix it in with all the other flavors. I think we served up a pretty tasty dish.

MONTY: "Much of what I do is fast and efficient because the concepts move directly from my head to the screen. In terms of organization, I keep my moments and beats organized by simultaneously editing while animating. I keep constant track of how a sequence plays as a whole and review as often as possible."

ONWARD AND UPWARD

That workflow became the model for how we tackled *Red vs. Blue* production for the next two seasons.

We learned that trying to put animated shots back-to-back with machinima shots is extremely difficult. Even when the animated shots looked amazing, they often looked wrong next to the machinima. In some ways, that discovery motivated us to separate the animated sequences from the machinima. That's why the narrative for Seasons 9 and 10 are constructed the way they are, with the animated sequences in a different timeline than the machinima sequences. When you don't have to cut directly from animated to machinima shots in the same scene, it makes the process much easier. We also enjoyed being able to play around with the look of the animated sequences more and really give them their own distinct tone and atmosphere.

MONTY: "I make it a point to study characters as deeply as possible. What I do can best be described as visual writing. I give the characters the opportunity to express things that were only implied in the past. I often start with a seed planted by Burnie, usually a simple idea like breaking through a wall we've always seen on screen, and coming up with several gags around it."

All of that culminated in Season 10.

There was a lot going on in Season 10 that we'd never done before. The scale of the entire season was huge, with space battles and all kinds of craziness, plus more animation than we'd had in the last two seasons combined. Even though we write it and produce it like a feature film, it's important to remember that most people experience *Red vs. Blue* episode by episode, week to week. There's something really satisfying about crafting an individual episode that has a really well-written story arc and hits with comedy, action, and narrative all in the space of a few minutes.

Just like in previous seasons, we wanted Episode 10 of Season 10 to be a landmark episode, but we'd set the bar so high on action with Seasons 8 and 9 that there didn't seem to be much room to maneuver.

What we ended up doing was using the current (machinima) timeline story as bookend pieces that opened and closed

> MONTY: "With the Episode 10 fight, there were no storyboards involved because solely animating the shots meant there was no need to communicate it to others. Burnie trusted me and was able to closely oversee what I was doing because he was two desks away and could simply walk over and see what I was up to.

the episode, and presented the Freelancer part of the story as a flashback that would have immediate resonance in the present. (Seems simple, but we actually had to move around several entire episodes and huge scenes to get it to work with the overall season structure!) I loved the way we used CT's helmet as the device to make this happen, especially in the final scene where we reveal the secret behind who CT really is. Episode 10 has always been Tex's episode, and she certainly plays a big part, but there's no denying that episode belongs to CT.

Monty and I did almost the entire fight scene between the two of us, with him animating and modeling and me lighting, rendering, and compositing. It was one of the few scenes we did that year that didn't go through the full animation team, because honestly, I just wanted to have fun working on one myself. My goal was to create a really dramatic, noir-ish lighting setup that would distinguish it from previous fight scenes and emphasize the contrast between the different characters' motivations. It's got some of my favorite looks of the season, but endless rendering problems made it one of the very last scenes

we completed before mastering the DVD. It was really down to the wire. I lost a lot of sleep on that one.

Of course the icing on the cake was the music in the final scene where CT dies. Jeff and I had been planning out all these character themes since Season 9, and had already selected CT's theme and used it in earlier episodes, with the goal of it finally peaking in Episode 10 with her death. Then at the last minute, Jeff says, "Yeah, yeah. I decided to do something totally different."

Typical Jeff. But in typical Jeff fashion, he was one hundred percent right. As soon as I laid in the temporary version of the song "Forever," I knew it would be a great and unique moment for the series.

It's an episode I couldn't have imagined us making ten years earlier, and I'm really proud of how we were able to evolve the show over the years to make it possible.

GEORGIA ON MY MIND

BY EDDY RIVAS

>>>>>>>>>>>>>>>>>>>>>>>>>>>>

Season 10 cowriter Eddy Rivas tackles the Freelancer set piece that kicked off the season, and what it was like as a longtime fan to help fill in the backstory for such a beloved series.

"I don't think I could ever let anyone else write Red vs. Blue.*"*

Burnie Burns said these words to me in April 2008 while we walked through downtown Austin toward the former Rooster Teeth office on South Congress. Later that day, my

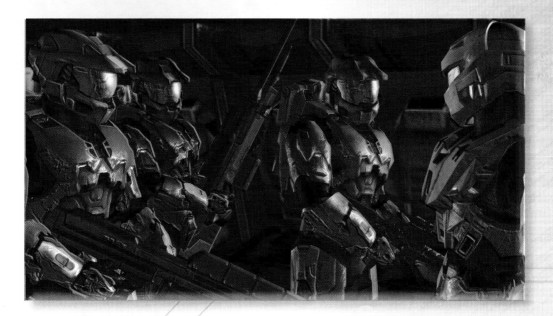

friends and I, another machinima team based out of Houston, Texas, helped puppeteer the opening shots of *Season 6: Reconstruction*.

Imagine my surprise when, in 2011, after Burnie recommended me for a job that didn't pan out, the *Red vs. Blue* creator extended me a different offer:

"Let's work together, then."

I first watched *Red vs. Blue* in a sweltering garage LAN party during a brutal Texas summer in 2003. While my friends swapped videos over a network that even Private Tucker would find questionable, I browsed a folder titled *Red vs. Blue*. I ripped through four or five episodes in one sitting while the rest of my friends traded insults and frags. I copied all of *Red vs. Blue* Season 1 to my hard drive to finish when I got home.

By the time I returned to Florida State for my junior year of college, I was a sponsor. I showed *Red vs. Blue* to anyone who would watch it (likely the cause of a few girls never calling me back). I joined the Rooster Teeth community site on launch day, and I've got a "first 5,000" badge to prove it. I followed speaking engagements and read staff journals.

The idea of creating my own machinima series became so compelling that my best friends and I did so a few years later, using *Counter-Strike: Source*. Many around the machinima community subtitled *The Leet World* as "The *Red vs. Blue* of *Counter-Strike*," a moniker in which I always took great pride.

So when it came time to pen my first words for *Red vs. Blue* Season 10 as a cowriter (along with the extremely talented and current series lead Miles Luna), it was a dream come true.

Writing for *Red vs. Blue* was like writing glorified fan fiction—and it was awesome.

THE PROCESS OF PUNCH-UPS

My first task as a new writer on *Red vs. Blue* Season 10 was to punch up the first draft. Punch-ups make the tension crunchier, help the jokes stick their landings, and pull the juiciest bits to the forefront.

To practice, I rewatched several seasons of *Red vs. Blue*. Any time I saw an opportunity for a better joke, I tried to add my own, and ended up with new treatments of old episodes. What was even more useful was the epic Season 10 table read, which gathered the entire cast

for a first-ever read-through of the script in advance. Watching from a dark corner, I marked up my first draft by hand any time an intended joke didn't get as big of a laugh as it could have, or if too much time passed between laughs from the cast. I took my draft home and spent a solid week with it—my first attempt at writing *Red vs. Blue* jokes.

Burnie's process for reviewing punch-ups is fairly straightforward. He went through my list of changes, joke by joke, and rated them on a scale of 1 to 3.

```
1: Loved it
2: See the need for a better joke here, but not this one
3: Not needed/hated it
```

Here's a sample of a punched-up scene. My changes appear in red, along with Burnie's ratings of each change.

```
INT UNSC ARCHIVE -- PRESENT DAY
EPSILON CHURCH still can't believe his rotten luck.

                    CHURCH
        Agent Carolina! What are you doing here?

                    CAROLINA
        I need your help. I'm tracking the
        Director of Project Freelancer and you're
        my best bet for figuring out what hole
        he's hiding in.

              2     CABOOSE
        Oh! Have you tried the big white hole
        with all the water in it? That is where I
        like to hide things sometimes. Like my
        butt rock collection.
```

 3 CAROLINA
 You mean the toilet? You think the
 Director of Project Freelancer is
 hiding . . . in a toilet.

 3 CABOOSE
 (gasps)
 He's in the toilet?!? He could be
 stealing my butt rocks!

 CHURCH
 Shut up, Caboose. What are you doing
 alive, Carolina? You're supposed to be
 dead! This is impossible!

 SARGE
 That's a funny thing to say for a guy who
 is literally a ghost.

 CABOOSE
 Um . . . actually he's not a ghost. He's a
 computer program. He gets holographically
 projected by our armor when he wants to
 talk to us.

 2 SARGE
 Pornographic computer programs? Heh!
 Caboose, you say the craziest things
 sometimes. What an imagination on you.

 2 CABOOSE
 I do not know what that first word means,
 but it sounds the same. I will allow it.

WASHINGTON, clad in light blue armor with a yellow
stripe, backs into the room, shooting back through
the door.

 WASH
 How we doing in here?

 CHURCH
 Wash?

 WASH
 You got Epsilon out? Good. We can't hold
 them off out there much longer. They're
 not too happy about us breaking in.

 CAROLINA
 Let me see what I can do to help that.

Carolina heads out the door, firing.

 WASH
 Same old Carolina. I guess coming back
 from the dead doesn't change anybody.

 CHURCH
 Washington? Why are you wearing blue
 armor? Why are you wearing MY armor?

 WASH
 Oh . . . um . . .

 CABOOSE
 Oh right . . .

 WASH
 They sort of used me to . . . replace you on
 Blue Team.

 CHURCH
 Replace me?

 CABOOSE
 I wouldn't really use the word
 "replace," but there's no word for "take
 over for you and make everything better
 almost immediately" -- so we just say
 replace.

 CHURCH
 When did this happen?

 CABOOSE
 Remember when you went into the memory
 unit and everyone was sad?

 CHURCH
 Yeah.

 CABOOSE
 It was right after that.

 CHURCH
 Right after I left?

 CABOOSE
 Well not right after. It was like five or
 ten seconds.

 CHURCH
 You're kidding me.

 CABOOSE
 Life is short, Epsilon. We had to move
 on.

 1 CHURCH
 I think I just got dumped by Caboose. Un-
 fucking-believable.

 1 CABOOSE
 It's not me. It's you.

It's easy to see what needs to be removed. In addition to not being funny, Caboose's toilet gag extends the beginning of the scene at a time when it needs to dive right into resolving Season 9's cliffhanger. However, when you consider the Freelancer action sequence leading into this scene, finding a *quick* beat of humor in the first lines might be necessary. In the final version, this becomes a "too-soon" joke about Private Donut's love for holes.

This process was repeated for every scene, and helped identify problem spots and dull edges. This is probably where I should admit to purposefully changing Sigma lines, just so I could say after the fact that I wrote lines for Elijah Wood.

Feels good to get that off my chest.

DELETED SCENES

A first draft is a block of marble. The real statue is somewhere beneath the hunk of stone, needing to be chipped away one piece at a time.

My second job on Season 10 was to help reveal the sculpture of the Freelancer saga. As a longtime viewer, I was able to bring a fan's perspective to this, with an exact idea of what I wanted to see in the Freelancer flashbacks—Wyoming's knack for knock-knock jokes, for instance, or Wash's rookie status before his inevitable descent into madness, courtesy of Epsilon.

One thing I immediately wanted more of after my first read-through of the script: glimpses into Tex and Omega's doomed partnership. However, in a season stuffed full of characters that had a lot of ground to cover, my favorite scene fell to the script guillotine for understandable reasons.

Tex and Omega

```
INT TRAINING ROOM OUTER HALL DAY
Tex stumbles into the hallway, past a sleeping sol-
dier. He nearly falls out of his chair as he wakes
up. Tex slumps forward against the opposite wall.

                    TEX
              (whispering angrily)
        Omega, what was that? I told you not to
        get in the way that time. That was my
        fight. Not yours.

Omega appears on her shoulder.

                    GUARD #1
        Oh . . . uh, Agent Texas. I was just . . . God,
        you're not going to tell the Director are
        you? I don't always sleep on the job,
        it's a thyroid thing!

Tex ignores him.

                    TEX
        Omega. Answer me, dammit. What the hell
        was that back there?
```

 GUARD #1
 Agent Texas? Are you OK? Let me call for
 help.

The guard reaches for his radio. As soon as he
touches it, Omega disappears. Behind Tex, the guard
convulses. Tex turns to face him, confused. She can
hear Omega's whispers sound in the cold, empty
hallway.

The guard stops convulsing. His demeanor changes.
It's subtle, but it's enough for Tex to notice.
She takes a tentative step toward him.

 TEX
 Omega?

The guard stares at her.

 TEX
 Private. Can you tell me your name?

The guard peers down at his name badge. It reads
 O'MALLEY.

 GUARD #1
 (voice deepening)
 Has a nice ring to it.

 TEX
 Omega. Inside my head. I mean it.

He does nothing.

 TEX
 The slots in these guards' helmets are
 only meant for emergency AI transport.
 You need to come back. Now.

 GUARD #1
 As you wish.

The soldier convulses and drops to the floor. Tex
shudders as Omega returns to her suit.

```
                      GUARD #1
            What? What happened? Hello?

He stands to find the hallway empty.

                      GUARD #1
            I really need to stop stealing Maine's pain
            meds.
```

Since Season 10's flashbacks butt right up against Season 1, I wanted a scene that showed Omega's famous escape mechanism—jumping radio frequencies. This scene originally followed Tex and Carolina's sparring session. When Tex later tells North she doesn't want to rely on her AI anymore, this is part of what fuels her decision. What I always loved about this scene was Tex realizing just how capable Omega was on his own, should she turn against him. It's an unsettling moment for her.

Burnie expressed some reservations about naming the soldier O'Malley, since the name was originally a combination of Omega and Allison—but I thought it would be a way to poke fun at the eventual name Omega takes for himself, and to have it appear in some way in Season 10.

I recorded lines for hapless O'Malley, so this scene made it to the final draft before getting cut during production. In the end, the decision was made that the scene would look more like a mistake in continuity than fan service (see: Season 3 joke where Tex sarcastically tells Donut her codename was "Nevada").

It hurt me to see this one cut. It's still my favorite scene from the script, next to Carolina's visit to York's final resting place in Episode 12. A necessary subtraction that strengthened the flow of the season, and probably prevented fan uproar.

But I still miss it.

STARTING WITH A BANG

After a couple of passes, Burnie gave me another job: start the season with a space battle. It had always been his and Monty's dream to include space combat in *Red vs. Blue*, since ship-to-ship slugfests take top billing in many of the *Halo* novels.

I was given a simple premise, and told to have fun with it: York is trying to pick a lock. The audience, having no idea of his actual location, is surprised when the wall behind him blows open and he's sucked into an explosive zero-gravity battle.

In the *Halo* novel *First Strike*, Insurrectionist forces are concealed by an asteroid field. I wanted to create a similar setup for the "rebels" in Season 10. Since the big MacGuffin of the Freelancer scenes was the data leading to the ancient temple, it seemed obvious that the setting should provide this data, or else the set piece turns into window dressing with zero effect on the plot.

Enter the scrapyard of derelict ships known as Bone Valley, littered with the husks of battle-ravaged cruisers. A UNSC ship that should have wiped its drives before being destroyed by the enemy was the perfect place to hide some data, and an excellent backdrop for high-flying Freelancer action.

Which obviously means Jet Packs.

"You don't want to end up like Georgia."

In another nod to the *Halo* novels, in which Spartan-005 James goes MIA by way of a Jet Pack accident, I created Agent Georgia to give the opening sequence a running gag and have some fun at Wash's expense. Because let's face it, the guy could use some levity every now and then.

I can't even recall how many times fans asked me what happened to Georgia at RTX 2012.

To me, the great thing about the fan response to this joke is that it comes from wanting to know the ins and outs of *Red vs. Blue's* mythology. Just like I had watched the show for years from college apartments and later at my first jobs in the corporate world, people watched scenes I wrote and wanted to know more. I'll always be grateful for having had the experience of stepping into this huge show from the outside, and watching the sculpture form slowly.

Also, I'm not sure what it says about me as a writer that my lasting legacy on *Red vs. Blue* will be a grappling-hook-to-the-groin gag, but I'll take it.

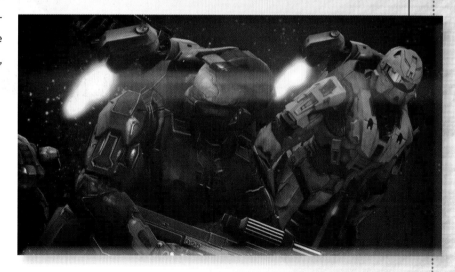

EVERYTHING OLD IS NEW AGAIN . . . AGAIN

BY MILES LUNA

Seasons 11–13 writer/director Miles Luna breaks down the Chorus storyline, elaborating on the unique opportunities and challenges he faced in creating a new normal for Red vs. Blue.

I've got a secret to tell you.

When I first began writing for *Red vs. Blue*, I was twenty-two years old, fresh out of college, and absolutely terrified.

Red vs. Blue Season 10 ended a decade-long story arc. The mysterious and omnipresent Project Freelancer, pulling the strings behind everything the Reds and Blues had ever encountered, finally met its end. We saw the Freelancers in action and we witnessed their inevitable downfall. At the same time, we watched the Reds and Blues put their differences aside, come together, and finally stand up to the corrupt organization that put them in a canyon in the middle of nowhere in the first place. And if that wasn't enough, the evolution of Matt and Burnie's storytelling abilities, combined with the talents of Eddy Rivas and animation direction of Monty Oum, grabbed the once humble web series by its bootstraps and raised it up to an extraordinary level of production value.

And even if you set that one huge season aside, there were nine others just as packed

with laughter, drama, and over-the-top action. *Red vs. Blue* was *the* web series, the sci-fi comedy watched by millions of people around the world. It was *Halo*. It was revolutionary. It predated YouTube. It was "*Clerks* meets *Star Wars*." It was Red versus Red, Blue versus Blue, I against I, me against you . . . and they were promoting *me* to be the writer/director of the series? My reaction can be summed up as follows:

How in the hell are we gonna top that?

BACK TO THE BASICS

The truth is you can't top something like Season 10. You have to try something new. And in our case, something new meant something *old*.

When I began work on *RvB* Season 11, Burnie and Matt expressed a desire to return the series to its roots, forgoing animation to rely solely on machinima and comedy to tell the beginning of a new story. As a huge fan of *The Blood Gulch Chronicles*, I could easily get behind this idea.

The "new story" part of the plan, however, proved to be more difficult. In my early talks with the creators, I was given a one-page sheet of beats and ideas. Several beats sparked plot points and gags that grew into integral parts of the season.

```
REDS AND BLUES CRASHED.
NO CHURCH OR CAROLINA.
BLUE TEAM NOT HAPPY WITH WASH. (TUCKER TRIES TO IM-
PEACH WASH?)
PROMETHEAN GRENADES = TELEPORTATION CUBES. OPPORTU-
NITY FOR GAGS WITH REDS.
END WITH SOME SORT OF NEW CONFLICT/REVEAL CAROLINA
```

It wasn't exactly what you'd call an ideal launchpad.

My next course of action? Speak with die-hard fans of the series. I spent time chatting with Barbara, Brandon, Kerry, and several other people at Rooster Teeth who had grown up watching the show. What were their favorite seasons? Who were their favorite characters? What had they never seen the Reds and Blues do before, but always wished they had?

These conversations helped tremendously. Simple questions like, "What if Caboose had a pet?" led to the creation of Freckles. Not only was Freckles funny, he served as a great replacement for Church in Caboose's eyes, which spawned the idea of Blue Team's life after Church, which led to the conflicts between Wash and the Blues, the theme of loss and moving onward, and so on and so forth. It was an incredibly fun time in the writing process.

But the last beat on Burnie's list had yet to be addressed: END WITH SOME SORT OF NEW CONFLICT.

A NEW NORMAL

The Reds and Blues had seen it all. They had faced the goofy yet sinister O'Malley, gone toe-to-toe with the might of The Meta, and even managed to overcome The Director and all of his forces. What was next?

We toyed with the idea of using the Flood character models, but the zombie thing felt overdone. We then considered robots. After all, some of the *Halo 4* armor sets looked pretty mechanical and scary. In the end, though, the new conflict came out of a discussion I had with Brandon Farmahini and Chris Demarais.

"What if you took soldiers from a make-believe war, and put them in a very real war, with very real stakes?"

It was perfect. It was everything I wanted from *Red vs. Blue* but didn't realize until that moment. I felt like I could see it almost immediately. It wasn't going to be "the Reds and Blues crack jokes while the Freelancers kick ass," it was going to be "the Reds and Blues crack jokes while they somehow manage to kick ass in their own, ridiculous, idiotic way of doing things." This was what could make our new storyline stand out from previous seasons.

MAKING BAD GUYS

Everything fell into place. A storyline focused on war required a villain who embodied war itself. I spent what felt like an eternity browsing the armor sets and combinations in *Halo 4* and eventually found a helmet labeled "Locus." Something about its round contours unsettled me. It was terrible and wonderful.

This villain needed to be more than formidable—he needed to be unstoppable. Burnie and Matt had set the bar high with The Meta, but I wanted to take that bar, place it in the hands of this new villain, and make people fear he'd beat them to death with it. Still, I wasn't sure if Locus would be enough. What if people thought he was too similar to The Meta? What if he came off as too over-powered? He needed something else. He needed a partner. I went back to the armor sets. The Locus helmet was round, so I hunted for contrast: angles, hard surfaces, sharp slopes. I grabbed the Scout helmet, threw on Venerator shoulder pads, dressed him up in black and green (later orange), and put him next to Locus.

Locus and . . . Scout . . . guy. Whatever. Names could come later.

I'd be remiss if I didn't mention the amazing music by Nico of *Trocadero* here. I've always felt that *Trocadero* and *Red vs. Blue* go hand in hand. Locus's chilling guitar melody came from a series of *RvB* transitions Nico sent me. In the middle of all the pleasant strums and little jingles, there was one series of notes I latched on to. They were part of a longer tune that had a sort of Spanish ring to it . . . but these few notes together sounded like they could become something more. After some messaging back and forth, we found what you hear today. It's short, simple, and somewhat unnerving when combined with the droning sound that Nico concocted. And it's perfect for Locus.

STARTING A WAR

But what about this very new, very real war in which our characters were going to take part? Since we were back to machinima, story decisions were again dictated by the video game engine we were using to make the season. And seeing as *Halo 4* didn't feature a playable alien model in multiplayer, this war was going to have to be man against man. Sort of like the fake "Red vs. Blue Civil War" from the early seasons.

A civil war ... now there was an interesting concept.

But where could this war take place? It couldn't really involve the UNSC, and if it didn't involve them, that meant it couldn't be on Earth or any other nearby planet. Come to think of it, I wasn't really sure where the *RvB* series took place geographically. It had always been sort of purposefully ambiguous ... but then again, this was a new chapter in the series.

I imagined a new planet, far away and forgotten in time ... all it needed was a name. I looked at other colonies in the *Halo* universe and, after some thought, decided on "Chorus." A group of people, singing in unison ... a tragically poetic meaning for a planet consumed by civil war. Now we had our villains, we had our setting, and we had our new arc ... but something was still missing.

WHO AGAINST WHO

A good story entertains the audience, but a great story makes the audience think. To tackle a subject as serious as war, I wanted to take a serious approach (or at least as serious as *Red vs. Blue* can get). This war would not be black and white. "Good" and "evil" don't exist in real wars. Real wars have casualties and people doing terrible things on both sides.

But of course, that's not the way people tend to think about wars in stories. I wondered if we could create some misdirection, and that's when I looked to Scout-Guy, or as he would later be known, Felix. Throughout Seasons 11 and 12, Felix provides the perfect amount of false guidance to both our heroes and the audience. First, show the typical Hollywood interpretation of war: an evil empire, rebels in need of saving, and a big bad man with a big bad gun who was big and bad and oh-so-obviously evil. It was purposefully predictable, and I remember reading more than a handful of negative comments during those early episodes. But then came Episode 18 of Season 11 ... and people. Went. Nuts.

Agent Washington, Sarge, Donut, Lopez, and Freckles were gone.

The game had changed. Viewers were no longer certain that the Blood Gulch Gang was safe anymore. There was tension again, tension that had been missing for quite some time. For ten years, we watched as the Reds and Blues overcame all odds, and Season 11 looked as though it would follow a similar path. But this was my chance to do something new. I took a predictable victory and replaced it with defeat. Our heroes would have to learn to be heroes again, or at the very least, they would have to try.

And in the end, that message is the beat I wanted to hit most. *Try.* It resonated deeply with me.

I've got one more secret for you.

At the time I'm writing this piece, I'm also working on Season 13. Weird, right? To tell you the truth, I'm actually running a bit behind schedule. I'm not entirely sure how viewers will react to this new chapter of *Red vs. Blue*. Like Wash in Season 11, I was thrust into a position of responsibility I wasn't sure I was ready for.

But that's not the secret I want to tell you.

When you look at the body of work that is *Red vs. Blue*, and you're the one standing before an audience of millions, and you're asking yourself, *"How in the hell are we gonna top that?"*

The secret is that you can't top it. You try something new. And then you try again. So that's what I'm going to keep doing.

Dear Chairman,

I am disappointed by your decision to press charges, but I am not surprised. My only hope is that the courts will see the matters differently than you have. You see, I never had the chance to serve in battle, nor did fate provide me the opportunity to sacrifice myself for humanity as it did for so many others in the Great War. Someone extremely dear to me was lost very early in my life. My mind has always plagued me with the question, if the choice had been placed in my hands, could I have saved her? The memory of her has haunted me my entire life, and more so in these last few years than I could ever have imagined. But given the events of these past few weeks, I feel confident that had I been given the chance, I would have made those sacrifices myself.

Had I only the chance.

I know that you disagreed with my methods and that others will as well. This is beyond my control. However, I cannot imagine that *any* court would be able to convict me, no matter how low their opinion of my actions might be. You must understand one basic fact for all this to make sense, my dear Chairman. These AI, they all come from somewhere. They are all based on a person. Now Alpha was no exception. And while the law has many penalties for the atrocities we inflict on others, there are no punishments for the terrors that we inflict on ourselves.

So you send your men. They won't find themselves a fight. They'll only find an old man. An old man tired, but satisfied he did his duty. An old man weary from a mind more filled with memory than it is with hope.

Sincerely Yours,

Dr. Leonard Church

The Former Director of Project Freelancer

CONCLUSION

RED, BLUE, AND BEYOND BY BURNIE BURNS

If there is a secret sauce to *Red vs. Blue*, it's this: we like making it. I know they say that if you enjoy what you do, you never work a day in your life. The benefits extend beyond that. At its heart, *Red vs. Blue* is just a bunch of people playing a video game the wrong way. That applies to not only the characters but to the creators as well. It's been a major part of the longevity of the series. The show has changed so much over the years, but one thing remains constant—making movies in a video game is just a different way to play the game.

On a base level, most video games are essentially a tool to display a 3-D environment that you can manipulate in real time. The game provides lighting effects, renders, and even sound effects based on what the user does and displays it right back to them. What we call the game is actually the last step. It's the set of rules the developers tell us we should follow to interact with the world they built for us.

The inspiration for *Red vs. Blue* started the moment

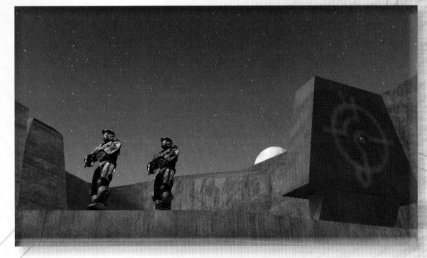

we suspended the rules of the game. Literally the second we lowered the pistols and said, "Let's not shoot each other, let's just walk around"—that is when *Red vs. Blue* started. I think that's appealing not only to people who watch the show but to the people who make *Halo* as well. Even after ten years of making the show (and fifteen years of *Halo* development), I still have designers tell us they can't wait to see what we do with their game. The feeling is mutual—I can't wait to see what they do with their game either.

It's been well over a decade since those early days of inspiration huddled over an Xbox with a copy of *Halo* in the drive. *Red vs. Blue* is now the longest running show on the Internet and the longest running science fiction show in American history. If our inspiration came from fun, our longevity can only be credited to our adaptability. So much has changed over the last fifteen years, especially in the way that people find and watch video content. At last count, 100 hours of footage are uploaded every minute to YouTube. If you wanted to watch every video on the platform, you would fall four days behind for every minute that you tried. That's over six months per hour or sixteen years in a single day. I could continue but you get the point—plus I should stop because I am falling way behind on watching videos.

It's an enormous noise floor and somehow, *Red vs. Blue* punches through and continues to find an audience. It makes me very proud. There have been a lot of little obstacles along the way, adding up to fairly sizable challenges over the years. There have been chances to take the show to television, opportunities presented by other companies, and always the constant artistic need to **finish the damn story**. We have embraced all of these in unique and adaptive ways; that flexible approach has made our story one of the longest on the web. And stories on the web do not typically last very long. When I first built the road map for *Red vs. Blue* in 2003, I had six episodes. Total. That would have lasted two months.

And here we are thirteen years later.

A lot has changed. An incredible team of animators have made the show shine in its more recent years, but also the game itself has changed. That latest game in the series, the upcoming *Halo 5*, will be the tenth game in the franchise. Having a show based on an evolving property has been uniquely challenging. If you put *RvB* Season 1 and *RvB* Season 10 in a lineup together, people might not even recognize them as the same show. I can't think of any series, on television or online, that has changed as much as our little baby has. Even other animated shows undergo changes in the fidelity of their art, but keeping up with a game has been a little ridiculous. As I write this, *Halo 5* is currently in the works on the third hardware platform. The world in which we shoot our show has constant updates. Not many other shows have that challenge.

And speaking of *Halo 5*—what does the future of *RvB* hold? Miles Luna has done an amazing job moving the franchise forward. The fans continue to watch the series that is still going thirteen years after its "six-episode run" was set to conclude in May 2003.

My philosophical approach to *Red vs. Blue* has not changed over the years. I always said that I would keep making the show as long as A) I was happy and felt like we were making great episodes, B) there was an audience that wanted to watch it, and C) Microsoft wants us to continue. Those three things continue after thirteen years.

And it doesn't show any signs of slowing.

ACKNOWLEDGMENTS

FROM THE AUTHOR

My biggest thanks go to my wife, Jen, for her loving support of my writing but most especially this book—even when it meant *Red vs. Blue* was playing in our living room for two months nonstop.

Lesser but still monumental gratitude goes to the amazing Miles Luna, without whose expertise this book would have been missing so much fantastic content. To Stephanie, for being a gracious boss who championed my regular trips to Austin to work on this project. To Kiersi, Queen of Words and Princess of Encouragement. To Emily, Koen, and Joshua at Rooster Teeth and Sean at HarperCollins for the miracle working and spreadsheet diving it took to get this thing to print. To Rachel Smith for the quick design assistance, and to Beth Kerner for the hilarious illustrations. To the Reds and Blues of Blood Gulch, who inspired me to create the projects that ultimately kick-started my career. To Burnie and Matt, the Guys Who Keep Giving Me Chances.

And last, to my girls, Talia and Eliana, who give me new reasons to write each day.

FROM BURNIE BURNS AND ROOSTER TEETH

So many have contributed to the production of *Red vs. Blue* over the years that it's impossible to thank everyone. However, we must express our immense gratitude to Frank O'Connor, Cameron Payne, Brian Jarrard, and Pete Parsons for immediately embracing our funny little video experiment and inviting us into the larger Halo community. The longevity of *Red vs. Blue* would not be possible without the ongoing support of the great people at Microsoft, 343, and Bungie, including Matt McCloskey, Christine Finch, Kiki Wolfkill, Bonnie Ross, Alicia Brattin, Jim McQuillan, and Joe Staten.

To all of the cast and crew, thank you for working tirelessly to expand the universe of the Reds and Blues. And finally, an impossibly huge thanks to our fans and community—we couldn't do any of what we do without you.

ABOUT THE AUTHORS

EDDY RIVAS is a writer from Houston, Texas, who loves science fiction and knows way too much about *Red vs. Blue*. A copywriter by trade, Eddy has written for numerous web productions in addition to *Red vs. Blue*, including Rooster Teeth's *X-Ray and Vav* and *Day 5*, as well as Smooth Few Films's *Web Zeroes* and the upcoming *The Leet World*. You can read more of Eddy's fiction and published work on his website, eddyrivas.com.

BURNIE BURNS is the founder of Rooster Teeth Productions and the creator of the award-winning web series *Red vs. Blue*. He graduated from the University of Texas with a degree in computer science. After a successful career as president of an Austin-based tech company, Burnie turned his attention toward creating online video and had an early viral hit with a parody of the "Apple Switch" ads. He quickly followed with the first *Red vs. Blue* trailer and formed Rooster Teeth shortly thereafter. He has since been recognized around the world as an innovator and leader in the field of online video.

Burnie Burns is currently the Chief Creative Officer and head writer for Rooster Teeth. He also voices the main character "Church" in *Red vs. Blue* and stars as "Hagan" in Rooster Teeth's first feature film, *Lazer Team*.

Dear Chairman,

It has come to our attention that you have declared war on the planet Chorus. We regret to inform you that this is a *really* shitty idea. Not only have you managed to annoy the people that you failed to kill time and time again, you've also found a way to annoy an entire planet!

Now, they may not have the best equipment, and they might not be the best fighters, but as you are aware, they've been fighting for a *very* long time. And now that they're not fighting each other, they're more than happy to dedicate all of their time to fighting you.

So, dear Chairman, to you and your idiotic mercenaries, we would like to say: "Bring it on, motherfuckers."

We're not going anywhere.

From your friends,
The Incredibly Badass and Sexually Attractive Red and Blue Soldiers of Project Freelancer

P.S. Suck our balls.